RINGING THUNDER

Inner coffin from the burial
of Shao Tuo, Baoshan Tomb #2,
polychrome lacquer over wood,
4th century B.C.

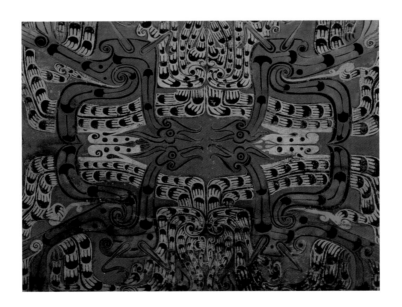

WHEN A RULER SUCCEEDS TO HIS STATE, HE MAKES HIS COFFIN, AND THEREAFTER VARNISHES IT ONCE A YEAR, KEEPING IT DEPOSITED AWAY.
- From the *Liji* (Book of Rites)

RINGING THUNDER
Tomb Treasures from Ancient China

Selections of Eastern Zhou Dynasty Material
from the Hubei Provincial Museum
People's Republic of China

CARON SMITH, Curator of Asian Art, San Diego Museum of Art
SUNG YU, Curator Emeritus of Far Eastern Art, San Diego Museum of Art

Additional Essays by
SHU ZHIMEI, Director of the Hubei Provincial Museum
CHEN ZHONGXING, Vice Director of the Hubei Provincial Museum
WANG JICHAO, Chief of the Chinese History Research Department of the Hubei Provincial Museum
JOSEPH C. Y. CHEN, Professor of Physics at the University of California, San Diego

SAN DIEGO MUSEUM OF ART

1999

Published by The San Diego Museum of Art, 1450 El Prado,
Balboa Park, San Diego, California 92101

This catalogue is published in conjunction with *Ringing Thunder:
Tomb Treasures from Ancient China*, organized by the San Diego
Museum of Art with the support and cooperation of the National
Administration for Cultural Heritage of the People's Republic of
China, the Cultural Department of Hubei Province, and the
Hubei Provincial Museum. The exhibition is supported by an
indemnity from the Federal Council on the Arts and the Humanities.

Library of Congress Catalog Card Number 99-61729

ISBN 0-937108-24-3
Printed in the United States of America
Cover: Antlered crane, bronze, 5th century B.C.

Editor: Sara E. Bush
Designer: JoAnn Silva
Calligraphy: Chi Kang
Photography: All photographs courtesy the Hubei Provincial Museum

Typeset in QuarkXPress 4.0
Printed by Rush Press, San Diego, California

CONTENTS

PRESIDENT'S FOREWORD

The relationship between the United States and China dates back to the American Revolution. The right to trade directly with China for tea, without a surtax being imposed by Britain, was one of the sparks that ignited the Colonies' battle for independence. Chinese art came to America as a by-product of the trade between the two countries in the 18th century. Americans particularly admired Chinese porcelains, which often were used as ballast in trade ships. The great American silversmith, Paul Revere, modeled one of his best-known bowls on a Chinese pot that is now in the British Museum.

A more thorough American awareness of and appreciation for Chinese art, however, developed more slowly. Early in the 20th century, connoisseurship of Asian art was fostered through the efforts of several American museums, most notably the Museum of Fine Arts, Boston, and the Freer Gallery in Washington, D.C. The latter, which opened to the public in 1923, is primarily devoted to the arts of Asia. While certain American collectors pursued Chinese art-particularly objects emerging from the archaeological digs conducted in China prior to the 1930s-the American public remained largely ignorant of Chinese culture. In the American consciousness, China has been defined by the political and social movements that marked the middle decades of this century, and by the wars, isolation, and nationalism that accompanied them. At the same time, however, the immigration of many Chinese to the United States, and the birth of new generations of Chinese-Americans, have helped to forge a new process of cultural exchange.

With this exhibition, *Ringing Thunder: Tomb Treasures from Ancient China*, the San Diego Museum of Art is proud and pleased that, at the close of the 20th century, we enjoy an era of more open and fruitful cultural exchange with the People's Republic of China. In the late 1990s, two of the best-attended exhibitions in the United States were exhibitions of Chinese art, and we can now say that Americans stand in awe of Chinese artistry and seek to understand the profound cultural values that inform China's artistic accomplishments. This situation will bring value to our relations in all spheres and facilitate further understanding and cooperation.

Ringing Thunder presents an opportunity to share the revelations that archaeology and research in China have brought forth in the last twenty-five years, and we are grateful to Ambassador Li Zhaoxing in Washington, D.C., for recognizing the value of this exhibition and for approving the travel of these price-less relics of Chinese heritage to the SDMA. We offer sincere thanks to Zhang Wenbin, Director of the National Administration for Cultural Heritage, Wang Limei, Deputy Director of the National Administration for Cultural Heritage, Foreign Affairs Office, and Hu Meizhou, Commissioner of the Cultural Department of Hubei Province, who made the objects available to us. Ambassador An Wenbin, the Consul General in Los Angeles, has been a staunch supporter of this exhibition from its inception almost ten years ago. His personal love for these objects-unearthed in his hometown of Suixian, Hubei Province-has been contagious. Through his energy, the project was able to unfold. The Hubei Provincial Museum in Wuhan and its Director, Professor Shu Zhimei, have made invaluable contributions. This exhibition has proven to be an opportunity for extraordinary aesthetic and cultural enrichment, as well as for enduring friendships created through pursuing a shared goal. We would also like to thank the United States' Federal Council on the Arts and the Humanities, which provided federal indemnity for this exhibition.

Ringing Thunder was conceived of nearly a decade ago by Sung Yu, then Curator of Far Eastern Art at the SDMA. As with all projects of value, it was realized through the talent of many individuals. The project was embraced by the San Diego Museum of Art under the direction of Steven L. Brezzo and by the Hubei Provincial Museum. It was brought to fruition when Dr. Caron Smith joined our staff in 1997, as Curator of Asian Art. Our thanks are extended to the staff at both museums, who labored over several years to bring this exhibition into being. Special acknowledgment must go to those on the SDMA staff who brought this catalogue to fruition, Dr. Caron Smith, Sung Yu, Sara E. Bush, JoAnn Silva, Nancy Emerson, Jim Grebl, Dr. Holly Witchey, and Jeffrey Liddell.

Katy Dessent
President, Board of Trustees
San Diego Museum of Art

DIRECTOR'S FOREWORD

The Hubei Provincial Museum was founded in 1953, and is in charge of the archaeological excavations, relevant research, and the collection of artifacts within the province. At present, the HPM houses close to 100,000 artifacts that reflect the development of civilization during the pre-Qin era in the region of Hubei.

Ringing Thunder: Tomb Treasures from Ancient China is drawn entirely from the collection of the HPM. It represents an outstanding gathering of artifacts from the Zhou dynasty (1045-221 B.C.), with the majority from the Warring States period (476-221 B.C.). Over two-thirds of the objects in the collection were excavated from the justly famous tomb of the Marquis Yi, of the state of Zeng, who was buried in 433 B.C., in Suixian, Hubei Province. In one of the most exciting recent archaeological discoveries in all of China, the tomb of the marquis was excavated in 1978, revealing a wealth of objects that are stunning not only because of their beauty and rarity, but also because of what they have taught us about the literary and social cultures of this key period in Chinese history.

The state of Zeng was located in the middle region of the Yellow River and the Yangzi River. It had close connections to the kingdoms of the Central Plain and to the Chu state in the south. Because of Zeng's ties to other areas, its culture reflected an unusually high degree of development. The Zeng tomb artifacts are noteworthy for their representation of impressive scientific, musical, and artistic achievements. The highlights are indicative of the depth of this find:

- the set of sixty-five bronze bells is the largest multitonality system ever excavated;
- the set of thirty-two marble chimes is famous for the variety of tone arrangements and the artistic value of its bronze rack;
- the musical instruments discovered include examples of nearly all instruments known at that time;
- the bronzes demonstrate mastery of manufacture through the lost wax process, the inlay of precious stones, and plate soldering with riveting details of breathtaking excellence;
- the jade carvings confirm the period's intense sense of beauty;

- the weaponry, with copperplate or goldplate engravings, provides an idea of the level of warfare technology;
- the lacquerware demonstrates high artistic achievement, and has presented an opportunity for scientists to demonstrate the success of new conservation techniques.

Given the fragility of many of the objects found in the tomb of the Marquis Yi and the other, related tombs, this exhibition is limited to the types and numbers of pieces best able to travel. Yet the selection is still representative of the more than 10,000 objects that were excavated.

Since the 1980s, good relationships and joint activities have been sponsored by American and Chinese museums, and Chinese antiquities have been brought over to the United States many times for exhibitions. As far as I know, however, this exhibition represents the first time for such a large exhibition of bronzes produced in the Yangzi River valley, and from a single museum outside Beijing. The San Diego Museum of Art, as a prominent museum situated on the eastern portion of the Pacific Rim, was a logical and complementary location for such a venture. This exhibition has come into being with the support of the National Administration for Cultural Heritage and the Cultural Department of Hubei Province, as well as many American friends in all professions. This exhibition provides an opportunity to explain to an American audience the long and splendid history of China, and to further the understanding between our two nations. I am pleased to have had this opportunity to express my gratitude to both American and Chinese supporters of this exhibition.

Shu Zhimei
Director
Hubei Provincial Museum

CURATORS' NOTE

The collection of the Hubei Provincial Museum, numbering over 100,000 objects, has been cared for and on view in Wuhan for the past two decades; as of 1999, it is housed in new buildings that enhance the display and storage of these astonishing works of art. We congratulate the HPM on its contributions to the preservation and understanding of China's cultural heritage.

It is the fortune of an international audience of scholars and the public that the HPM and the People's Republic of China have taken an interest in making this astonishing cultural record available for exhibition outside of China. The curatorial team at the San Diego Museum of Art would like to express its gratitude to the staff of the HPM for their generosity and professionalism in making this international exhibition unfold smoothly. Director Shu Zhimei has been involved over a long period of time in bringing to light these objects-including their documentation, housing, and display. We are particularly grateful to him for his expertise, kindness, and interest in this project for almost a decade. The staff at the HPM-Professor Chen Zhongxing, Feng Guangsheng, and Wang Jichao-were experienced colleagues, ready to share their knowledge and to extend their help in the myriad details of arranging a multinational, multi-lingual exchange. We look forward to further opportunities to work together.

On its side of the Pacific, the Board of Trustees and the Director, Steven L. Brezzo, of the SDMA accepted the challenge of enabling this exhibition to occur. The museum's staff then met the challenge enthusiastically. We would like to thank the registrars, designers, and preparators who labored on the physical installation, as well as all those who supported its production-the development, education, library, programming, merchandising, accounting, security, administration, and public relations teams. Each person on the staff-too numerous to mention by name-deserves our special thanks. Professor Chi Kang kindly lent his erudition and his distinctive calligraphy to our cause, and the Chinese-American community in San Diego offered consistent support.

Recent publications and others' scholarship have greatly aided our discussion of these objects and their cultural contexts. The authors especially relied upon Li Xueqin's *Eastern Zhou and Qin Civilizations* (Yale University Press, 1985), Thomas Lawton's *New Perspectives on Chu Culture* (Smithsonian, 1991), Michael Loewe and Edward L. Shaughnessy's *The Cambridge History of Ancient China: From the Origins of Civilization to 221 B.C.* (Cambridge University Press, 1999), and David Hawkes's *The Songs of the South* (Penguin, 1985). We hope that this volume brings the work of dedicated scholars to a new audience.

Caron Smith
Curator, Asian Art
San Diego Museum of Art

Sung Yu
Curator Emeritus, Far Eastern Art
San Diego Museum of Art

MAPS

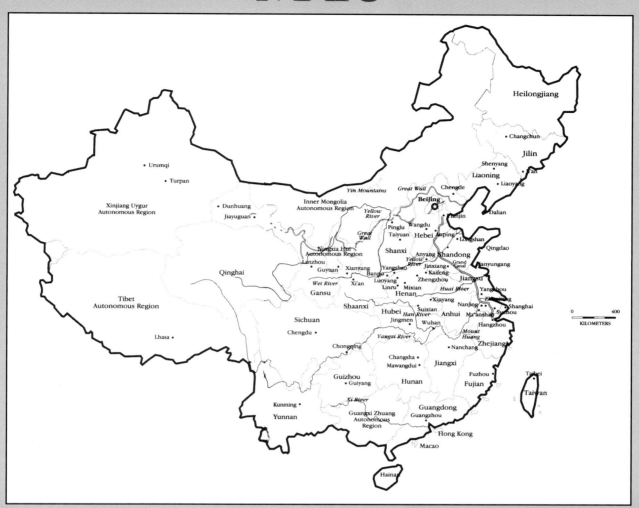

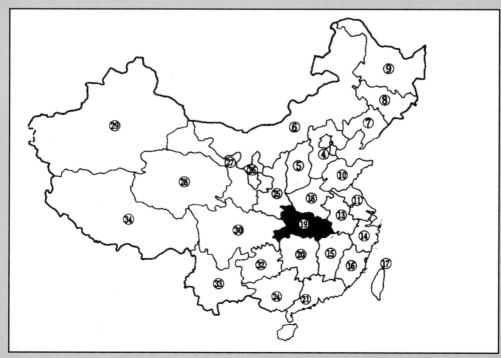

Map 1 - Contemporary China
(Adapted from *Three Thousand Years of Chinese Painting*)

Map 2 - Hubei Province (19)
(Adapted from *Zhonghua Renmin Gongheguo Fen Sheng Dituji*)

Map 3 - Early Civilizations
(Adapted from *The Archaeology of Ancient China*)

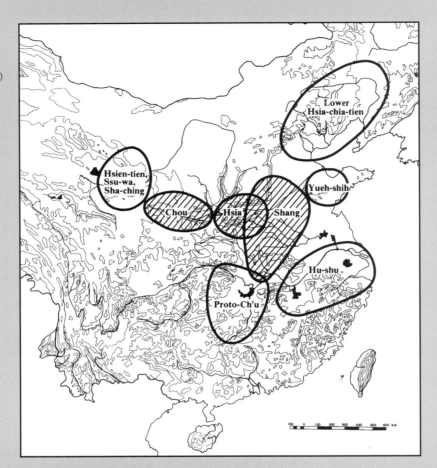

Map 4 - The Seven Strong States of the Warring States Period
(Adapted from *The Songs of the South*)

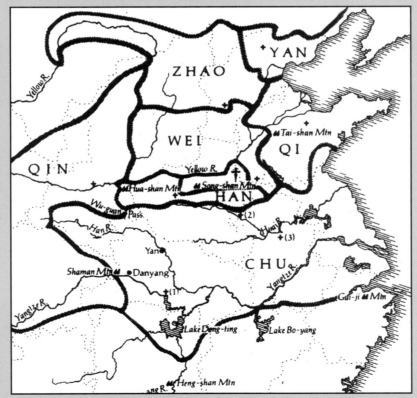

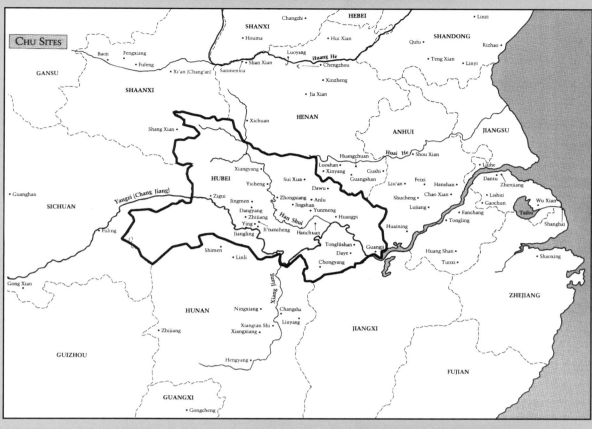

Map 5 - Chu Sites
(Adapted from *New Perspectives on Chu Culture*)

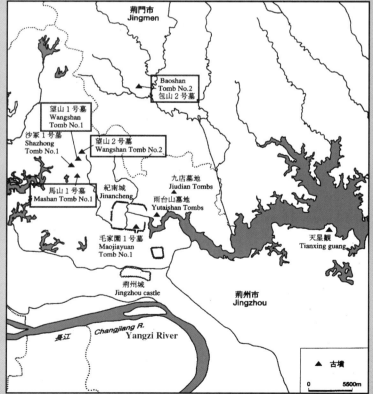

Map 6 - Map of Chu Tombs, Near the Capital, Jiangling, in which Objects in this Exhibition were Found
(Adapted from *A Mysterious World of Ancient Designs*)

CHRONOLOGY OF CHINESE DYNASTIES

EARLY DYNASTIES

Xia dynasty ..1900-1350 B.C.

Shang dynasty16th century-1045 B.C.

Zhou dynasty..1045-221 B.C.

 Western Zhou dynasty.....................1045-771 B.C.

 Eastern Zhou dynasty....................... 770-221 B.C.

 Spring and Autumn period722-481 B.C.

 Warring States period476-221 B.C.

IMPERIAL CHINA

Qin dynasty ..221-206 B.C.

Han dynasty206 B.C.- A.D. 220

 Western Han206 B.C.- A.D. 9

 Xin interregnum...9-23

 Eastern Han...23-220

NOTE ON PINYIN

Chinese is rendered in English in this catalogue using the *pinyin* system, which was introduced in the People's Republic of China in the 1950s. As the official romanization system in China, it has been widely accepted and now supplants the older Wade-Giles system. Pinyin is pronounced as it looks, with a few notable exceptions.

PINYIN	PRONOUNCED	
c	ts	(as in plants)
q	ch	(as in choose)
x	sh	(as in shoe)
zh	g	(as in surge)

POWER

THE EXHIBITION

It is rare that the past reveals itself in so vivid a concentration as is afforded by the objects excavated in Hubei Province from tombs of the late 5th through the late 4th centuries B.C. While these objects were found in a context related to the rituals and beliefs surrounding death, they also serve to disclose a great deal about daily life some 2,400 years ago. All objects in this exhibition were drawn from the collection of the Hubei Provincial Museum and most were excavated between 1965 and 1987. The vast information about ancient Chinese civilization that has come to light through archaeology over the past thirty years has set all previous learning from textual and historical sources against a new backdrop of interpretation. The interaction of these sources of learning has produced confusion and disagreement at times, but scholars concur that a new dimension of understanding of China's past has been achieved. This exhibition focuses on a part of China's Yangzi River basin that has been revealed to have a new importance, and illuminates a period of constant warfare, cunning statecraft, competing philosophies, and cultural fusion-a period of enduring consequence for the development of imperial China.

The objects in this exhibition provide a glimpse of ancient China as revealed by various avenues of knowledge-rich literary traditions, historical writing, archaeology, and the encounter between our senses and works of art. The question that is pursued throughout this exhibition is what we can observe about the interweaving of the Zhou culture of China's Central Plain, which was moving southward from the Yellow River area, and the Chu culture, which was moving northward and eastward from the Yangzi River area. The individual objects, and the dynamics of their collection as groups, provide answers to this inquiry.

This exhibition focuses on objects from the Warring States period, from three tombs located within a few hundred miles of one another and spanning approximately four generations, between 433 B.C. and 300 B.C. They bring to light the different cultural identities that existed within this narrow band of space and time. One tomb was located in the state of Zeng, which maintained strong links with the Zhou feudal structure into the 5th century B.C.; the other two reflect the imprint of the culture of the state of

Map 3

Map 6

Map 4

Chu, centered in the Yangzi River basin. Earlier material from the Zeng-Chu region has been added to the exhibition to illustrate antecedent traditions.

1. **TOMB OF MARQUIS YI**
 State of Zeng
 Known as Tomb #1, in the locale of Leigudun, Suixian District, Hubei Province
 Dated to 433 B.C., during the early Warring States period of the Eastern Zhou dynasty
 Excavated 1978-79

2. **TOMB OF SHAO TUO**
 State of Chu
 Known as Tomb #2, in the town of Baoshan, Jingmen County, Hubei Province
 Dated to ca. 316 B.C., during the middle Warring States period of the Eastern Zhou dynasty
 Excavated 1987

3. **TOMB OF AN ARISTOCRAT**
 State of Chu
 Known as Tomb #1, in the town of Wangshan, Jingzhou District, Jiangling County, Hubei Province
 Dated to ca. 300 B.C., during the middle Warring States period of the Eastern Zhou dynasty
 Excavated 1965-66

These three burials reveal the cultural development of China along its path to unification as a great, enduring empire. They allow examination of the interpenetration of the Zhou culture of the Central Plain of the Yellow River region and the Chu culture of the Yangzi River region.

Map 3

The Yellow River culture achieved its dominance during the thousand years of rule under the Xia, Shang, and Zhou dynasties, from the 19th through the 9th centuries B.C. This dominance is asserted in written histories generated in the north of China; these histories form the canon of Chinese traditional thought and guided the archaeological inquiry. The culture of the central Yangzi River region developed at the same time as that along the Yellow River, but is as

of yet incompletely understood, and seems to have been transmitted less through written records and enduring materials such as bronze, than more fragile oral and wooden or bamboo records. The objects in this exhibition provide fertile ground for understanding Yangzi River culture-its similarities with and differences from Central Plain culture-as manifested in grave plans and practices, ritual paraphernalia, and luxury goods.

To understand the significance of these finds in the context of the emerging picture of complex regional interactions, we must step back and examine the larger structure of geography and political history.

GEOGRAPHY AND EARLY CHINESE CULTURES
The early cultures in China, as did many cultures around the world, developed along rivers. Two rivers of paramount importance are the Yellow River and the plain it forms known as the Central Plain, and the Yangzi River.

Map 1

The Yellow River
The Yellow River flows from the Tibetan plateau across northern China, depositing rich silt for the cultivation of crops on the Central Plain and tracing a shifting course toward the sea. Neolithic culture (characterized by the practice of settled agriculture) and Bronze Age culture (defined by the use of a strong metal alloy of copper, tin, and lead for tools and weapons) had developed along the western reaches of the Yellow River from at least 5000 B.C. In this region, the historical dynasties of the Xia, Shang, and Zhou established their capitals and developed cities, a system of writing, a legacy of poetry, and artifacts of dazzling technological skill.

The long-held view that China's root culture emerged from the Central Plain is being tested continuously by new archaeological finds that show multiple centers of early cultural development. Each year, particularly since the end of the Cultural Revolution, the resumption of archaeological practices informed by Western methodology has recast and refined the story of history. The finds from Hubei Province that comprise this exhibition are part of that deepening story.

The Yangzi River
In a journey of about 4,000 miles, the Yangzi River drops from the Himalayan ranges, makes a hairpin

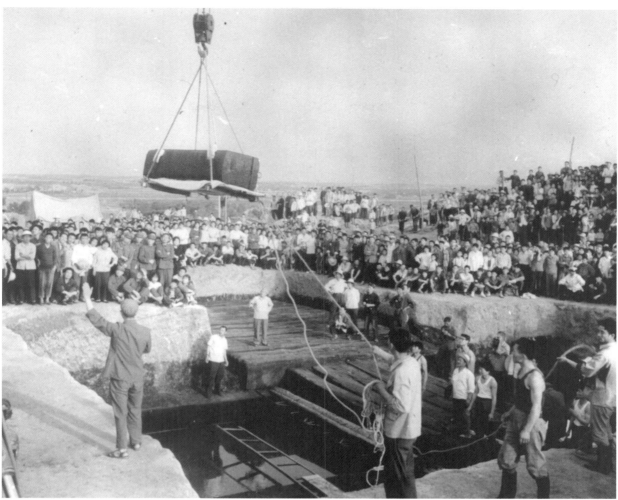

Removing the coffin of the Marquis Yi

turn northward in northern Yunnan Province, and journeys across the Sichuan basin through narrow gorges to emerge as a mighty navigable river flowing eastward across south-central China. The Yangzi reaches the East China Sea near the modern city of Shanghai.

There is physical and textual evidence of the penetration of the Shang from the Yellow River into the region of the Yangzi River during the reign of the Shang king Wuding (r. 12th century B.C.) The Yangzi River region was known to the Shang as *Jing-Chu*. This same area, encompassing both banks of the Yangzi, in the area of modern Hubei Province, appears in the records of the Zhou dynasty as a state called Chu. The archaeological finds in the region over the last twenty-five years have been astonishing. Warring States period artifacts (such as those from Wangshan and Baoshan in this exhibition) substantiate the textual evidence of the Central Plain influence on rites and technology of Chu culture, but also reveal that the Chu state maintained its strongly distinctive belief systems and artistic traditions.

HOW DATES IN CHINESE HISTORY ARE DETERMINED

Early Dynasties

Xia dynasty ..1900-1350 B.C.

Shang dynasty16th century-1045 B.C.

Zhou dynasty1045-221 B.C.

 Western Zhou dynasty1045-771 B.C.

 Eastern Zhou dynasty.......................770-221 B.C.

 Spring and Autumn period722-481 B.C.

 Warring States period476-221 B.C.

The periodization of Chinese history according to dates in the Western calendar is based on historical documents, inscriptions, and calculations of astronomical events. The dates assigned to the Warring States period vary, but 476 B.C.-the first year of the "Annual Table of the Six States" in the *Shiji* (Records of the Historian), China's great synthetic history

written by Sima Qian in the 1st century B.C., is usually taken as the beginning. The closing date for the period is sometimes given as 256 B.C., the year in which the state of Qin brought down the last Zhou monarch ruling as the "Son of Heaven." Other times the closing date is extended to 221 B.C., the year in which Qin defeated its final enemy and entirely united China under its rule. The Warring States period therefore covers the last two and a half centuries of Zhou dynasty rule.

Map 5

The Zhou dynasty had begun its reign with the conquest of the Shang dynasty, set by convention at 1045 B.C. A division in Zhou rule is marked by the transfer, in 770 B.C., of the capital from a site near modern Xi'an, Shaanxi Province, eastward to a site near modern Luoyang, Henan Province. The period between 1045 and 771, when the Zhou capital was in the west is known as the Western Zhou, and the period after the move east is known as the Eastern Zhou.

The Eastern Zhou period is itself divided into two parts that are named in accordance with the historical records that chronicle them. The first three centuries of the Eastern Zhou are known as the Spring and Autumn period, after the *Annals of the State of Lu*, supposedly compiled by Confucius, which covers 722 B.C. through the usurpation of power in the state of Qi by the Chen lineage in 481 B.C. The second half of the Eastern Zhou is the Warring States period, whose name is aptly derived from the battles for supremacy among China's states.

The Zhou dynasty ruled for over 800 years, and although its power diminished in the Warring States period, it was long remembered as one of China's golden ages, when shared rituals sustained unity, and the loyalties of kinship set the standard for just rule. Powerful forces emerged during the Warring States period to disrupt this unity and the ties of kinship-including the diversity of regional cultures and the need for locally derived administrative structures adequate for the tasks of a materially advancing culture. These challenges fostered exploration of new intellectual, political, economic, and social models. Needs for mass production spurred technology, and the arts flourished in an age of broad and conspicuous consumption. This drama of China's evolving civilization is manifest in the grave goods of Warring States aristo-

THE ORIGINS OF YANGZI RIVER BASIN CULTURE
SHU ZHIMEI

Now, at the end of the 20th century, we are in a position to appreciate how the concentrated efforts archaeologists have made in the past few decades in China have brought about great discoveries and advanced our knowledge of the Yangzi River basin's role as one of the cultural cradles of China. Archaeologists have been able not only to distinguish among the region's varied cultures, but also to trace scientifically the sources and formations of different cultures and their ultimate blending into a unified China.

Fossils of *Homo erectus* dating to the Paleolithic period have been found at Wushan and Yunxian (along the upper-middle reaches of the Yangzi River), and at Hoxian and Tangshan (along the lower-middle reaches). These finds constitute the earliest record of human activity in the Yangzi River basin. Primitive farming tools and Neolithic artifacts have been found at Hemudu, toward the lower reaches of the Yangzi, and at Chengbeixi and Daxi, in the middle reaches of the Yangzi. The earliest farming achievements in the Yangzi River area are comparable with those of the Yellow River region. In 1995, the earliest evidence of rice cultivation-12,000 years before the present-was found at the site of Yuchanyan, in Daoxin County, Hunan Province.

The center of the Hubei region is the plain between the Han and Yangzi rivers. It is the most important site in terms of the area's cultural development. In the 1950s, fossils of *Quxi Yuanren*, a type of *Homo erectus*, were discovered in Yun County, as were fossils of Changyang Man, an early *Homo sapiens*. Other discoveries have related to the Neolithic cultures of the Chengbeixi (ca. 5500-3000 B.C.) and the Daxi (ca. 2600-2000 B.C.). Although archaeological evidence shows the differences between these two cultures (and, over

crats included in this exhibition-aristocrats displaying wealth and power in death as in life.

We must explore the political and social structure as well as burial rituals of Warring States China to understand the meaning that such grave goods might have had. Objects of such lavish manufacture speak a language of social and political power as well as of ritual efficacy and technological accomplishment.

time, within each), both were based on rice cultivation and fishing. In the late Neolithic period, improved communication brought about cultural exchange between the inhabitants of the Hubei region and their neighbors, especially with those of the Central Plain culture. From this period come signs of new developments-the building of towns, the beginnings of writing, and the creation of ritual objects.

In the middle of the Shang dynasty, the Shang people gradually penetrated south, reaching the north bank of the Yangzi, the plain at the confluence of the Yangzi and Hanshui rivers, and the plain by the Dontinghu Lake and Fengshui River. During the Western Zhou period, the influences of Central Plain culture traveled through the Suizhou and Zaoyang corridors to the area east of the Hanshui River. From there, they gradually spread through the Yangzi River basin and the entire Hubei region. The indigenous culture adopted the main features of Central Plain culture, most notably its rituals, written characters, and bronze vessels.

In the 8th century B.C., the Chu state became a power in the region of Jingshan and the ancient Juzhang River (the modern Nanzhangman basin). It encroached upon the Hanshui River basin and the areas to its east. During the middle of the Spring and Autumn period, the Chu state began to develop original, unique cultural traits. Until the end of this period, Chu culture was dominant through the Hubei region. When the Chu tried to expand their power northward, they were suppressed. The Chu then turned toward the east. By the middle of the Warring States period, the Wu and Yue states, in the region of the Yangzi and Huai rivers, were under the power of the Chu.

That the Chu culture was a branch of Central Plain culture is proven by the similarities of race, language, and family and clan structure. The Chu culture flourished because of its fusion of elements from the Central Plain culture and that of the Yangzi and Hanshui rivers region. Archaeological evidence shows that before the late 7th century B.C., Chu articles were basically similar to those of the Central Plain, but then grew more distinct and individualized. During the Warring States period, Chu culture came to be representative of the peoples of southern China in its worship of spirits, its fantastic and romantic poetry and literature, its splendid and complicated bronze vessels, and its radiant and colorful lacquerware and silks.

Great insight into the cultural flux of these periods has been provided by the objects excavated from the tomb of the Marquis Yi of the state of Zeng. The findings reflect the high accomplishments in metal molding, music, and art before the unification of China under the Qin dynasty in 221 B.C., and it is one of the most important archaeological finds of the 20th century.

The Marquis Yi had the same surname as the king of the Zhou court of the Central Plain (Ji), but his state was a much smaller one. During the early Zhou dynasty, an ancestor of Yi had received the enfeoffment of the land from the Zhou king. The state was situated east of the Han River and the middle portion of the Yangzi River. The enfeoffment was made so as to help the Zhou staunch the expansion of power of the Chu people native to that area and to protect the mining and trade of copper ore.

The Zeng state survived for 700 years before being swallowed by the Chu kingdom during the middle of the Warring States period. During its early period, it belonged to the system of the Central Plain culture; later, it was strongly influenced by Chu culture. The achievements represented by the treasures unearthed from Yi's tomb demonstrate that the level of civilization in the Hubei region was equal to or higher than that of the Central Plain culture along the Yellow River-a phenomenon that was the result of the cultural exchange between northern and southern China. After the Qin dynasty united China, the material culture of the Hubei region was again similar to that of the Central Plain, although many aspects of spiritual life continued to reflect the influence of the Chu.

POWER AND THE ZHOU POLITICAL STRUCTURE

The Zhou dynasty ruled its large territory by means of a feudal structure. The royal seats, in both the first and the second capitals, were fortified cities. After conquering the Shang, the Zhou established members of its clan, surnamed Ji, in surrounding settlements to administer the countryside and quell rebellious tribes. These policies extended Zhou culture along a network of allegiances based on kinship and direct relationships to the center of the state. The pyramid of Zhou power extended through kinship from the king, the Son of Heaven, to rulers in vassal states. Each ruler managed his own inherited fiefdom and could requisition a certain portion of the resources managed by his subordinates in a rigidly hierarchical society. This system was maintained during the Western Zhou period, extending Zhou ritual systems over a large area of the Central Plain.

POWER

THE CHINESE FEUDAL SYSTEM

The feudal system in China can be traced back to the late Shang dynasty. The history of this time is known through the study of oracle bones excavated from sites near Anyang, Honan Province.[1] The political and social organization of Shang society was rooted in feudalism, with many vassal states feoffed by Shang kings to court officials and relatives. All royal and important events were controlled by the Shang king, who was the superlative authority. The succession passed from the king to his younger brother, with the last four Shang kings passing power to their sons.

Besides holding fiefdoms as vassals, some independent tribal chieftains were also given the title of lord, as a means of pacifying them and neutralizing their opposition. The duties of vassals such as these included fighting battles with the Shang king's enemies, guarding the borders, and offering tributes.

Many oracle bones bear carvings with the ranks and titles of the Shang rulers. Similar inscriptions later appeared on Zhou dynasty bronzes. The Zhou inherited and adopted the Shang's system of central government. There were further connections between these two dynasties, even though the people formed separate nations. The Zhou court tried to absorb the advanced civilization of the Shang culture, and modeled its bronze weapons and vessels after those of the Shang. King Wu (the founder of the Zhou dynasty), his father, and his grandfather also had connections with the Shang through marriage. Wu's father, Wen (who posthumously received from the Zhou the title of king), was actually a Shang vassal.

Wu and his successor controlled the region between the western capital of Haojing, in modern Shaanxi Province, and Loyi (now Luoyang) in Henan Province-an area of around 1,000 li (330 square miles). During their two reigns, they granted more than seventy fiefdoms, which surrounded and protected the Zhou kingdom. By the end of the Western Zhou, the number of feoffments had passed 170.

The feudal system was based on a division of the land. The royal court awarded land to feudal vassals to establish states. The vassals then gave a portion of their land to no more than six *qing* ministers.

1 For dates of the feudal systems in Shang and Zhou China, see Fu Locheng, *Zhong Guo Tong Shih* (Chinese General History) (Taipei: Great China Library, 1978), 16-36.

The lords and ministers were the authorities in their land, and their titles and power were hereditary. The king could also grant *shi* (knight) titles, which came without any land but did make the recipient a member of the aristocratic class. Lower-ranking officials had obligations and duties to those above them. Below the aristocrats in the hierarchy were the common people. The lowest in the hierarchy were the slaves, owned by aristocrats.

The Zhou dynasty is unique in Chinese history for its division of aristocrats into distinct subcategories, of which there were five-*gong* (dukes), *hou* (marquis), *bo* (earls), *zi* (viscounts), and *nan* (barons). These categories were based on the amount of land held in feoffment. The cutoff for a duke or marquis was around 100 *li* (roughly 33 square miles); for an earl, around 70 *li* (roughly 23 square miles); and for a viscount or baron, around 50 *li* (roughly 17 square miles).

A few vassals who were related to the royal family enjoyed especially cordial relations with the court during the Western Zhou dynasty. These included the vassals of the states of Qi (now northern Shandong Province), Lu (now southern Shandong Province), Wei (now southern Hebei and northern Henan Provinces), and Jin (now Shanxi Province). Qi and Jin became protective states to the Zhou after the capital was moved east. Vassals who were not related to the royal family, such as those of the state of Chu in the south, often became hostile enemies of the Zhou court.

EASTERN ZHOU

King Ping (r. 770-720 B.C.) moved the Zhou court to to the eastern capital at Chengzhou (present-day Luoyang). The western region had been decimated by war and, Ping, similar to many Zhou monarchs, was challenged in his right to rule by sublineages. The threat to Ping came from his brother. Strong vassal states in the east (Qi and Jin) and west (Wei) supported Ping, and he wished to be nearer to them. From this time forward Zhou ruled in name only.

During the Spring and Autumn period, independent states battled to consolidate territory and power. They battled within themselves, against one another, and against barbarians-those with no allegiance to Zhou rituals-who surrounded them. Smaller states were absorbed by more powerful states, and the number of states was reduced from over a hundred

to a mere score. A notion of supremacy among the states, the *ba* (hegemon) system (*ba* means the superior one) emerged, and states battled for this rank as well as territory.

By the 6th century B.C., a multistate system prevailed in China, with balances of power achieved by both alliances and military contests, and by social and economic reforms that commanded loyalty. The power of a state depended on its ability to attract men of talent and merit as advisors and functionaries. The class of common gentlemen, *shi*, used their education in the arts of ritual, music, archery, charioteering, writing, and mathematics in order to take up administrative roles within the growing machinery of government. Merit became a means of social advancement.

THE WARRING STATES

Map 4

The burials yielding the majority of objects in this exhibition date to the Warring States period. The period was dominated by seven major states, with power consolidated around individual rulers. While boundaries were ill-defined-except in the cases where walls were built-these states were *territorial* units held together by power and loyalty to the state ruler, unlike the Zhou city-centered states held together by loyalty to the Son of Heaven. The major states were Qi, Yan, Han, Zhao, Wei, Qin, and Chu. Of this group, only the state of Chu lay to the south of the Yangzi River. In the middle of the 3rd century B.C., the state of Qin, in the far west, was to prove the victor in the battle for supremacy, uniting the states in an empire that gives us the name of China today. Although the first empire lasted for only fourteen years, it paved the way for the succession of dynastic power in a unified China that endured until 1911. After the Chu capital was taken in 278 B.C., only Zhao and a smattering of small states lay before them on the road to empire.

TERMINOLOGY

The term "Chu" is used in various ways by different scholars. It can be understood as meaning the following:

- a region that varied in size according to the historical period;
- a state, according to the *Shiji*, that was enfeoffed by King Cheng of Zhou (r. 1040-1006 B.C.) to Xiong Yi, who was not related to

THE KINGDOM OF CHU— NORTH AND SOUTH, THE DRAGON AND THE PHOENIX

WANG JICHAO

A description of the state of Chu is provided in *The Geographical Records of the History of the Former Han*, compiled by Ban Gu early in the 1st century A.D.:

> [Chu is a land with] fertile mountain forests and plentiful rivers and lakes of the Yangzi and Han [rivers]. The Yangzi valley is wide, and the land is fertilized with the burning of straw and weeds. The people eat fish and rice, and engage in fishing and woodcutting in the mountains. Fruits and gourds can be found everywhere, and there is usually enough food. However, the people are apathetic and weak-willed, so there is no population increase. They do just enough for food and shelter, so there are no wealthy families.

This is a Central Plain viewpoint of the southern culture. In the Central Plain, it took a much greater effort to sustain life and civilization. The drier climate of the Yellow River made hunting and gathering a necessary complement to agriculture. Hunting and gathering were far less efficient means of sustenance than agriculture and required a larger labor force in relation to the amount of food gathered, and hence a larger administration to organize the labor. This in turn led to a system of human government and control over nature rather than an acceptance of nature and its power.

The persistence of shamanistic beliefs in southern China after their diminishment in northern China is attributed by anthropologists to the richness of the southern climate and the more favorable conditions for life. Where nature is generous, the world appears interconnected; man does not need to assert himself above the natural order, but sees himself as a part of it. This primitive belief in spirits and gods in nature evolved into the philosophy eventually codified as Daoism.

In the 2nd century A.D., Wang Yi compiled the *Chuci* (Songs of the South), a collection of poems that had emerged from the Chu region during the Warring States period. He included a description of the religious beliefs and practices of the Chu state:

> In the area of the southern capital city Ying of the former state of Chu, between the rivers Yuan and Xiang, the people believe in spirits and sacrifices. During the sacrifice they had to sing and to dance ecstatically in order to please the different gods.

the Zhou line;

- a people of the Yangzi River region (who, in fact, belonged to a number of different tribes);
- the name of a culture. [2]

It is the last definition that is most appropriate for the issues raised within this exhibition.

THE STATE OF ZENG

We do not know a great deal about the state of Zeng. We do know that Marquis Yi held a title in the state of Zeng, but scholars are only now, thanks to the recent excavations, beginning to understand the nature of the state, its boundaries, its relationship to the Zhou feudal system, and its relationship, in the 5th century B.C., with the powerful state of Chu.

The boundaries of the state of Zeng are elusive, and even its existence is barely noted in the histories. Texts and archaeology together build the following picture.[3] Three states by the name of Zeng appear in the annals of the Spring and Autumn period. Two are in Shandong Province. The third is mentioned in an account of the defeat of King You (r. 781-771 B.C.) of that state. The state of Zeng was an ally of the displaced Zhou heir apparent, Ping (the son of the marquis of Shen), who had been set aside by a lady with whom King You had become infatuated. So enamored was You that he would entertain her by lighting the fires he used to summon his vassals, who became disaffected with these abuses of power. Ping then called on the tribes of Zeng and the barbarian Rong for assistance and defeated You, forcing the movement of the Zhou capital eastward to Zhengzhou. The state of Shen is identified as located within the southern area of modern Henan Province, and Zeng is presumed to have been a neighboring state of Shen, and so located in southern Henan and northern Hubei Provinces.

A number of excavated sites in southern Henan and northern Hubei, scattered along the Han River, support this theory. They have yielded vessels and objects identified through inscriptions with the state

of Zeng. According to where they were found and their style, they appear to belong to the late Western Zhou culture of the 8th century B.C. Only the tomb of the Marquis Yi-dated to 433 B.C.-reflects activity of the kingdom during the Warring States period.

The original Zhou enfeoffment of the state of Zeng is also murky. In 1980, halberds datable to the 7th and 6th centuries B.C. were found in a tomb located to the east of Suixian, Hubei Province. They identify their owner, by their inscriptions, as a direct descendent of the royal Zhou kings and a high official of the state of Zeng. His surname-as in the case of the Marquis Yi-would have been Ji, the surname of the Zhou royal house. Mention of the state of Zeng ceases to appear in literary records after 494 B.C., and the region from then on is identified as Sui. Scholars assume that Sui and Zeng must be the same state, but as of yet we have no explanation of why the name would have been changed or why Marquis Yi would have referred to himself as the leader of Zeng, and not Sui.

The questions of how long Zeng endured as an enfeoffed Zhou state and what was its political relationship to the powerful 5th-century-B.C. Chu state remain to be answered. Its cultural relationships, however, begin to be explained by the objects included in this exhibition.

THE BALANCE OF POWER IN THE 5TH THROUGH 3RD CENTURIES B.C.

Viewed in hindsight, the world of the Warring States period can be understood as having been dominated by the seven major states that emerged as self-gov- Map 4 erned territories between the 5th and 3rd centuries B.C. The first to exert itself successfully against the Zhou ducal line was the state of Qi, in the Shandong peninsula, where rich salt flats produced wealth, and whose strategic location made it critical to trade. The dominance of its ministers over the nobility was achieved by empowering new elements of society and by offering new civil advantages to a wider segment of society. This social and political development moved China out of a feudal system into new forms of administrative structure and policy.

The state of Jin's laws, derived from its own authority, were composed and cast onto bronze vessels. Jin forged new links among states through collective oaths that were no longer linked to Zhou.

2 These distinctions are set out by Li Xueqin in "Chu Bronzes and Chu Culture," in Lawton, *New Perspectives on Chu Culture*, 1.

3 H. G. Creel, *The Origins of Modern Statecraft in China*. Vol. 2, *The Western Zhou Empire* (Chicago: University of Chicago Press, 1970), 438-39.

The new allies swore to achieve the destruction of non-aligned states. By the end of the 5th century B.C., Jin's power had fractured into three independent states. The state of Wei emerged as the strongest successor state, but itself remained embattled on all fronts with the surrounding powers.

The state of Qin was the farthest west of the Warring States, and enjoyed relative security against attack by states to the east. It extended its domain southward into the agricultural basin of modern Sichuan Province between 441 B.C. and 316 B.C., and achieved year-round production of food, which in turn enabled its eventual conquest of the rest of the Chinese heartland in the 3rd century B.C.

Chu was the dominant state of the southern Yangzi River basin, with its center of power along the Han and Huai rivers. Always at some distance from Zhou power, its leader was the first to claim for himself the title of king. Chu coalesced as an independent power through its contests with neighboring states to the east, Wu and Yue. During the 6th century B.C., Wu matured as a state through the influx of sophisticated refugees from Jin. Wu began encroaching on Chu, pushing upward on the Yangzi River. At the turn of the 5th century B.C., Wu attacked the Chu capital and Chu was saved only through the intervention of Qin. Wu turned on its neighbor to the east, Yue, and in 494 B.C. the Wu king, Fuchai, crushed Yue, reducing it to the status of a tributary state. Yue then geared up for revenge and consolidated its power through a series of reforms, including tax remissions for nobles who had lost sons in war and for settlers in new lands. While Fuchai was traveling outside of Wu, Goujian of Yue attacked the Wu capital and captured Fuchai's heir. In 473 B.C., Wu was destroyed.

Pl. 1

During a time when many states were witnessing the decline of the Zhou line and a transfer of power away from the royal bloodline to collateral lineages or ministerial power, the wars between Wu and Yue actually resulted in a strengthening of the Zhou royal line at the Chu court.

After Yue defeated Wu, instead of pursuing a course westward, Yue turned its attentions to encroachments from the north. Without this distraction on its eastern flank, Chu expanded steadily during the 5th century B.C., annexing smaller states along its northern frontier and on the upper Huai River. The small state of Zeng lay in this path.

THE BO BELL OF THE KING OF CHU

The Bo Bell, in the set of sixty-five bells found in the tomb of Marquis Yi, carries an inscription of thirty-one characters:

> In the fifty-sixth year of his reign, King Hui of the Chu state received an obituary notice from Xiyang about the death of Marquis Yi. Hui had this ritual vessel made, and sent to Xiyang to offer the sacrifice on behalf of Marquis Yi, with prayers for his comfort in the afterlife.

Hui ruled from 488 B.C. until 432 B.C., so the fifty-sixth year of his reign would have been around 433 B.C.

The inscription was cast on the center trapezoid section of the bell. Since Zeng was a small vassal state surrounded and intimidated by the Chu power, why would the king of Chu have presented the sacrificial bell to the marquis? There is a story in Sima Qian's *Shiji* that Hui's grandfather, Ping (r. 528-516 B.C.), had executed two loyal officials, the father and brother of Wu Zixu, who then fled to the state of Wu and swore revenge. Wu Zixu won the support of the Wu king, and after ten years Wu troops invaded and captured Ying, the capital of the Chu state. For his revenge, Wu Zixu desecrated Ping's tomb and whipped his remains. In the meantime, Zhao, the son of Ping and father of Hui, fled and took refuge in Zeng. It was in gratitude for saving his father at such a precarious time that Hui had the Bo Bell made and sent to Zeng.

WARFARE

WARFARE AND THE IMPLEMENTS OF WAR

The Warring States period marked an important shift in the notion of the state, and this shift was accomplished in large measure through advances in the technology of war.

The climate of constant warfare can be understood as the history of battling states. In contrast, a more personal viewpoint of the consequences of war during the period is a poem in China's oldest anthology of verse, the *Shijing* (Book of Songs):

> *My lord is on service;*
>
> *Not a matter of days, nor months.*
>
> *Oh, when will he be here again?*
>
> *The fowls are roosting on their perches,*
>
> *Another day is ending . . .*
>
> *The sheep and cows have all come down.*
>
> *My lord is on service;*
>
> *Were I but sure he had drink and food!*[1]

During the Spring and Autumn period, war had been conducted by armies drawn from the aristocratic class, whose members were trained not only in archery and charioteering, but also mathematics, writing, music, and *li* (a combination of manners and knowledge of ceremony).

Each fiefdom commanded its levies and men who served as ministers were also commanders in the battlefield. Armies generally numbered no more than 30,000 men. Battles were confrontations on level ground of lines of chariots armed with men using the convex bow. What infantry there was used lances and was drawn from the lower reaches of society, who accompanied their aristocratic masters into battle.

All this changed during the Warring States period, which saw the development of universal conscription, the rise of infantry armies, a specialization in military command, and an elaboration of the strategic arts in such treatises as Sun Wu's *Art of War*. [2]

1 Arthur Waley, trans., *The Book of Songs* (New York: Grove Press, 1960), 100.
2 See J. H. Huang, trans., *Sunzi: The Art of War* (New York: William Morrow, 1993).

THE DEVELOPMENT OF THE ART OF STRATEGY

Sun Wu (Sunzi) was born in the state of Qi, but entered into the service of the king of Wu around 513 B.C., at a time when Wu had expansionist aims against Chu. Sun Wu was the architect of the state of Wu's defeat of Chu at the beginning of the 5th century B.C. His principles of strategy, as communicated in the text given his name, the *Sunzi*, were broad and comprehensive. Modern editions of his work continue to be used in businesses, political campaigns, athletic competitions, and international negotiations. Sun Wu's notion of war was largely how to avoid it; strategic deliberations embraced resourceful diplomacy and gave way to armed conflict only when necessary.

NEW CONFRONTATIONS, ARMIES, AND WEAPONS

The Warring States era saw a change in the patterns and scale of combat, the composition of the army, and the armaments used. Battles were conducted with large armies of infantry soldiers drawn by universal conscription from a broad range of society. The recognition of the peasant household as an element of state machinery was a highly significant development in Chinese social organization. The warrior nobility was reconfigured as an elite bodyguard, while the infantry war machine became an administered organ of the state.

Pl. 3

The professionalization of the soldier is described in the *Sunzi*:

> The elite [soldiers] trained to wear heavy armor, shoulder a large crossbow and heavy arrows, strap their halberds to their back, buckle helmets to their heads and swords to their sides, to carry food for three days, and to quick-march 100 *li* in a single day.

Armies numbered in the hundreds of thousands and battles took place on terrain unsuited to chariots. These innovations in weaponry can be seen in the objects that were buried next to aristocrats.

- The lance was lengthened to accommodate battles conducted from boats in the watery regions of Chu. The grappling hook was also developed for this reason. The dagger-ax was also lengthened.

Pls. 8 9, 11 13

- The axlike bronze halberd was given a long shaft to serve as a spear. The double edge

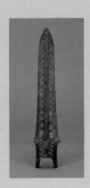

THE SPEAR OF KING FUCHAI

This well-crafted, cast spear belong to King Fuchai, who ruled the state of Wu from 473 B.C. until 469 B.C. It is decorated with rhomboid patterns. A center ridge on both sides runs from the socket to the spear point. Blood troughs were cast on the ridge of both sides. An animal head in high relief is set below the central rib on the socket of each side. There is an epigraph of eight characters inlaid with gold in two columns on the front side. It translates as:

Fuchai, King of Wu State
The spear for personal use

There is a slight bit of damage at the upper-left blade near the point. Even though it has been buried more than 2,400 years, the spear's resplendence has endured to modern times. The craft in the construction of this spear can be compared favorably with other unearthed swords, such as that of King Goujian of Yue, which were treated with rust-preventing chemicals.[3]

Fuchai of Wu and Goujian of Yue were kings of two states on the lower reaches of the Yangzi River. Goujian lost their first brutal war against each other in 494 B.C. He was humiliated and forced to beg for peace, which was promised by the victorious Fuchai. The defeated king of Yue lived frugally and kept vigilant in order to get revenge. He slept on firewood and tasted the bitterness of gall daily to remind himself of his irreparable humiliation. Finally, Yue rose up and defeated Wu in 473 B.C. Fuchai committed suicide. As swords and weapons made in Wu and Yue were renowned, his spear would have been a great prize for the conquering Yue troops.

How did the spear of King Fuchai come to be found in the Chu tomb known as Mashan #5? It may have come to Chu by way of Goujian's daughter, who married King Zhao of the state of Chu, some time between 515 B.C. and 489 B.C., or it is possible that it was captured by the Chu state when Chu defeated Yue in 355 B.C. The deceased in Mashan #5 may either have been related to Zhao or received the object as a gift from Chu royalty, perhaps for having played an important role in Yue's defeat.

3 Li Xueqin, *The Wonder of Chinese Bronzes* (Beijing: Foreign Languages Press, 1980), 66.

spearhead was in the form of a leaf, with a central ridge and a conical socket. The pole handle was thin at the top and thicker at the bottom. It had an octagonal wood core, applied with bamboo strips, bound in silk, and then lacquered in red. The butt was mounted with a cylinder of black horn and the adjoining areas were lacquered in black.

Pls. 7 8, 9 • The halberd on a long shaft was also combined with hooks for use in chariot fighting. The shaft was made of wood wrapped in slips of bamboo, tied securely with silk threads, and coated with lacquer. The weapon was straight, strong, smooth, and resilient.

Pls. 12 14, 15 • The winged arrowhead was replaced by a sturdier triangular form.

• Defensive shields were made more effective and elaborate. — Pls. 4 5

• Armor was made of lacquered leather, and pieces were light and flexible for fighting in the field. — Pl. 3

Weapons formerly known only from texts, such as the *shu* in the *Zhouli* (Rites of Zhou) were finally identified from finds in the Marquis Yi's tomb. This weapon with a triangular bronze blade and a socket cast with dragons fitted onto a pole handle is inscribed *shu*. This bronze three-edged sword is also identified as a *shu*. It is on an octagonal socket with dragons cast in high relief. Close infantry combat of large armies meant large-scale production of bronze swords, giving regions-such as Chu-that were rich in copper a military advantage. — Pls. 10 11

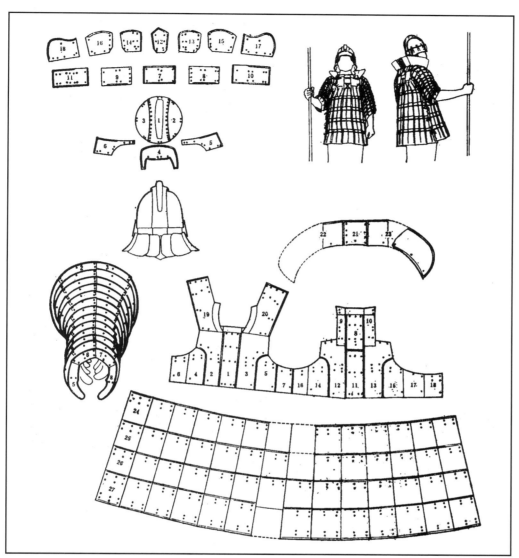

*Diagram showing the construction of the lacquered leather suit of armor (adapted from **Kaogu Xuebao**)*

WEAPONRY MANUFACTURE

The weapons unearthed from the tomb of the Marquis Yi include daggers, halberds, spears, bows and arrows, and bladed wheel axle caps. The metal used for these objects was a bronze alloy, generally ninety percent copper (from malachite ore), five to nine percent tin, and one to five percent lead.

The weapons were made in molds. A clay model of the weapon was pressed into mud molds, one mold per side, and then removed. The mud molds were then assembled and fired, and molten bronze was poured into the inner cavity.

Ancient texts tell us that some armor was made from the skins of rhinoceroses.

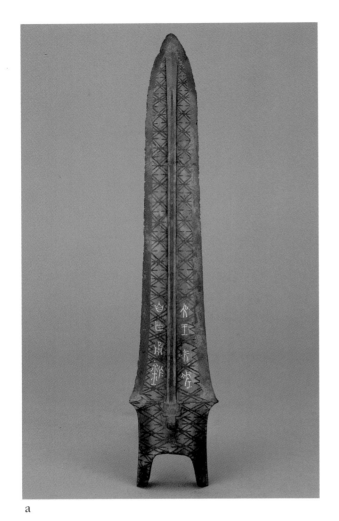

a

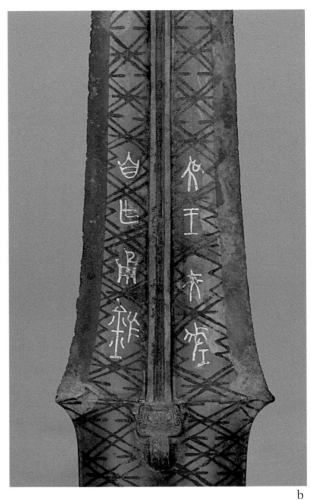

b

Plate 1

吳王夫差矛

SPEAR OF THE KING OF THE STATE OF WU FROM MASHAN TOMB #5
5th century B.C., Late Spring and Autumn or Early Warring States period
Bi-metallic cast bronze, 29.5 cm

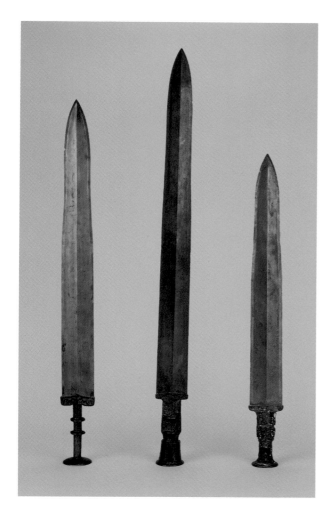

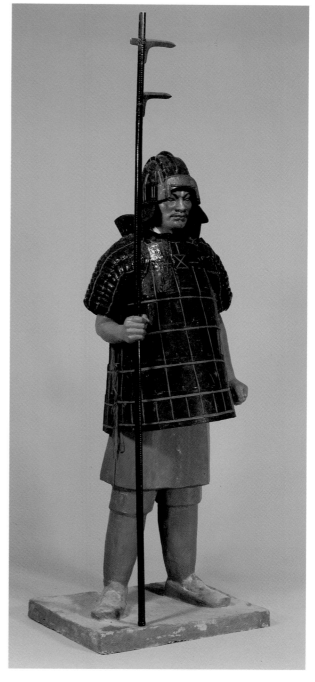

Plate 2

楚式銅劍

**THREE SWORDS FROM
WANGSHAN TOMB #1**
4th century B.C., Middle Warring States period
Bronze, varied dimensions

Plate 3

皮甲冑

**SUIT OF ARMOR
FROM SUIXIAN TOMB #1**
5th century B.C., Early Warring States period
Lacquered hide and silk thread, varied dimensions

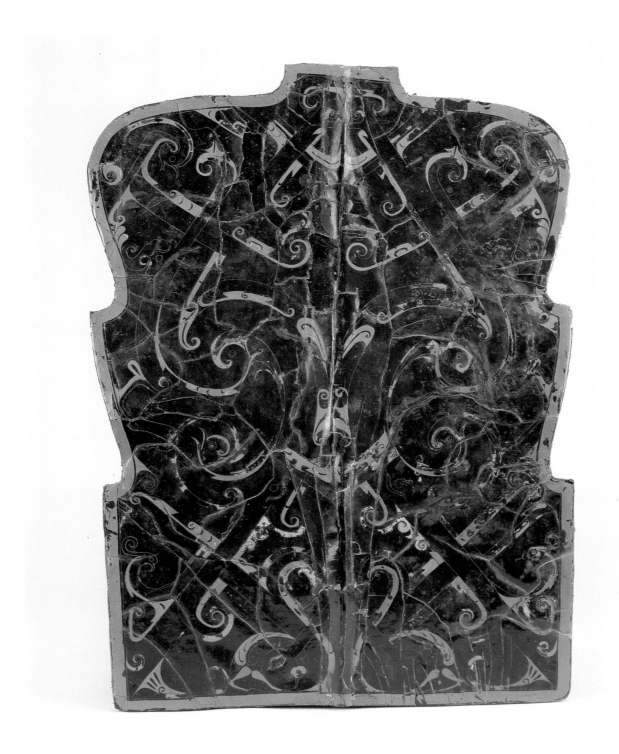

Plate 4

彩漆盾

SHIELD FROM BAOSHAN TOMB #2
4th century B.C., Late Warring States period
Polychrome lacquer, 46.8 cm

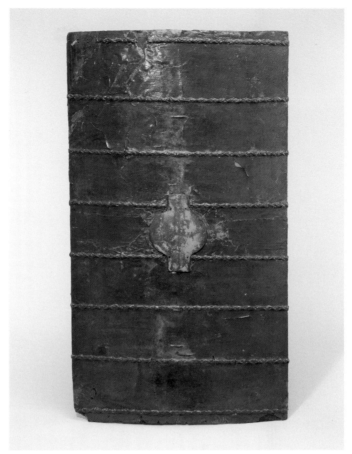

a

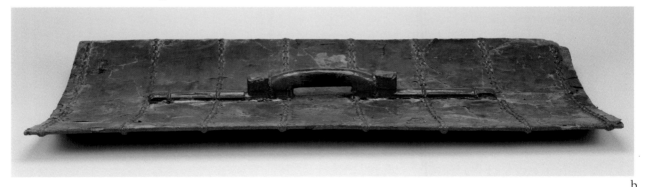

b

Plate 5

素漆盾

SHIELD FROM BAOSHAN TOMB #2
4th century B.C., Late Warring States period
Painted lacquer over wood, 92.4 x 49 cm

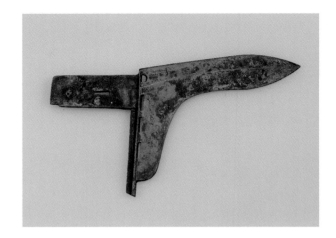

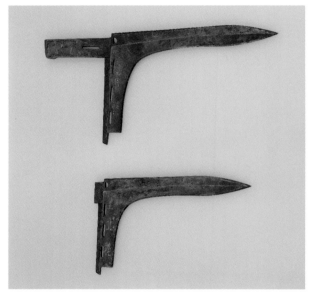

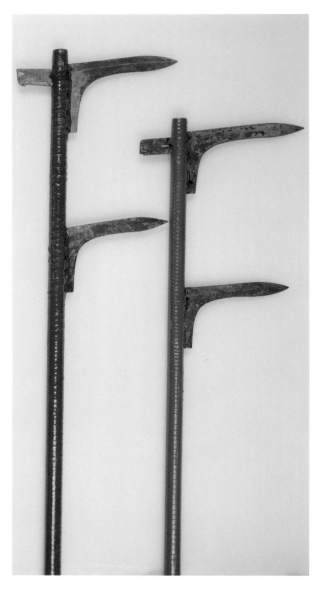

Plate 6

曾侯乙之走戈
DAGGER-AX
FROM SUIXIAN TOMB #1
5th century B.C., Early Warring States period
Bronze, 21.3 cm

Plate 7

曾侯郕之行戟
DOUBLE HALBERD
FROM SUIXIAN TOMB #1
5th century B.C., Early Warring States period
Bronze, 17.6 cm

Plate 8

長柄雙戈戟
DOUBLE HALBERD
WITH REPLICA SHAFT
FROM SUIXIAN TOMB #1
5th century B.C., Early Warring States period
Bronze, 294.5 cm

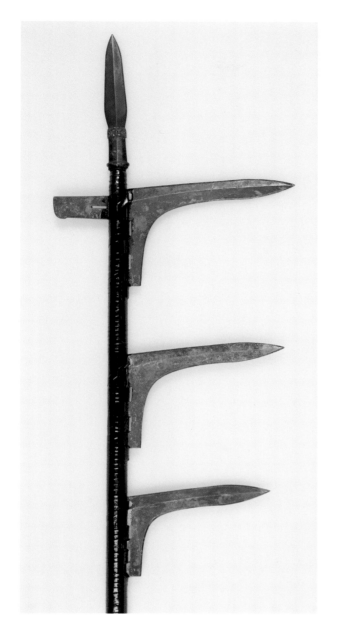

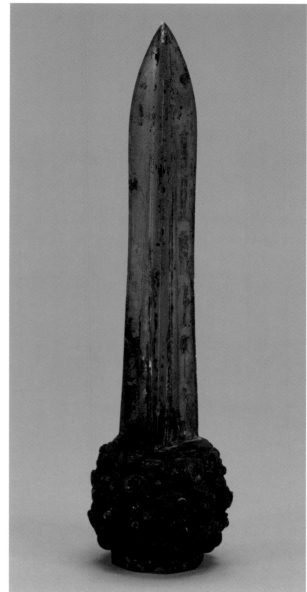

Plate 9

Plate 10

長柄三戈戟

曾侯郕之用殳

**TRIPLE HALBERD WITH REPLICA
SHAFT FROM SUIXIAN TOMB #1**
5th century B.C., Early Warring States period
Bronze, 325 cm

**THREE-EDGED SPEAR
FROM SUIXIAN TOMB #1**
5th century B.C., Early Warring States period
Bronze, 17.6 cm

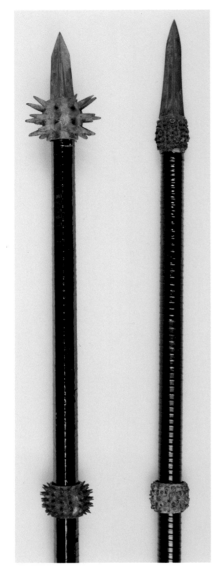

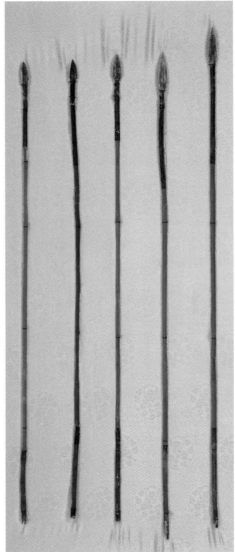

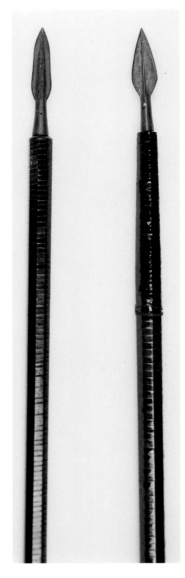

Plate 11

長柄殳

**THREE-EDGED SPEAR
WITH REPLICA SHAFT
FROM SUIXIAN TOMB #1**
5th century B.C.,
Early Warring States period
Bronze, 321 cm

Plate 12

帶桿箭

**TEN ARROWS ON
BAMBOO STICKS
FROM SUIXIAN TOMB #1**
5th century B.C.,
Early Warring States period
Bronze and bamboo, varied dimensions

Plate 13

長柄矛

**SPEAR WITH REPLICA
SHAFT FROM
SUIXIAN TOMB #1**
5th century B.C.,
Early Warring States period
Bronze, 223 cm

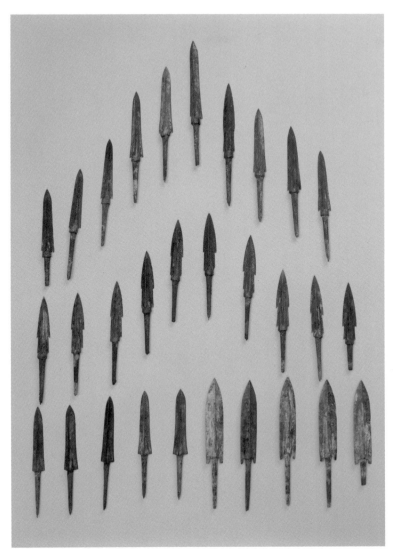

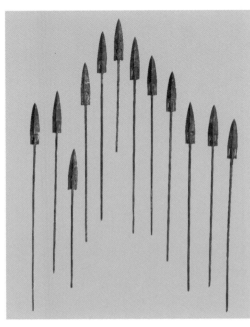

Plate 14

箭鏃

**FIFTY ARROWHEADS
FROM SUIXIAN TOMB #1**
5th century B.C.,
Early Warring States period
Bronze, varied dimensions

Plate 15

楚式箭鏃

**TWENTY ARROWHEADS
FROM WANGSHAN TOMB #1**
4th century B.C.,
Middle Warring States period
Bronze, varied dimensions

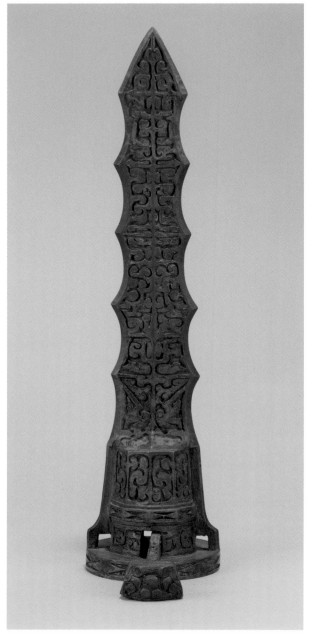
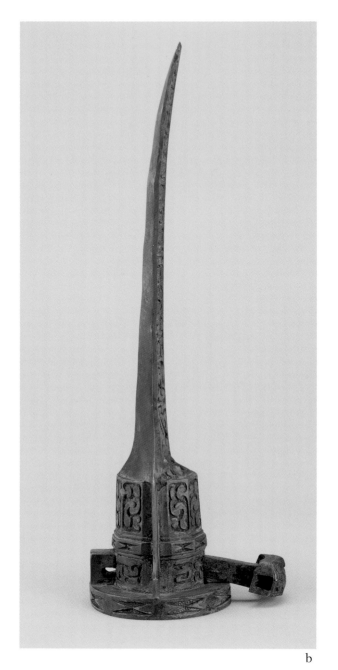

a b

Plate 16

帶矛車軎

**WHEEL AXLE CAP WITH BLADE
FROM SUIXIAN TOMB #1**
5th century B.C., Early Warring States period
Bronze, 41.4 cm

34

RITUAL

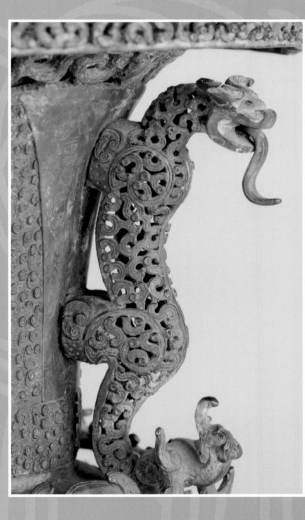

BURIAL RITES AND RITUAL PERFORMANCES-MUSIC, FOOD, AND WINE

The preservation of Zhou culture into the Warring States period, despite the political weakness of the Son of Heaven, seems to stem largely from continued adherence to Zhou rituals. Since these rituals governed burial practices, an examination of grave layouts and finds is one means of measuring the cultural relationship between the deceased and the Zhou system.

RITUALS AT DYING, DEATH, AND BURIAL

Texts that describe Warring States period burial rituals include the *Zhouli*, the *Yili* (Book of Etiquette and Rites), and the *Liji*. Discovery of intact tombs such as that of the Marquis Yi, greatly contributes to our understanding of these texts.

The rites of ancient China suggest the fundamental belief that the process of dying was the consequence of the soul wandering off from the body.[1] If a parent was in this state, the first responsibility of the son was to summon the soul to return. According to the *Yili*:

> A soul-summoner must take a suit of court robes formerly worn by the deceased, and having first pinned the coat and skirt together, he is to lay it over his left shoulder with the collar tucked into his belt, and in this manner, setting a ladder against the east end of the front eaves of the house, is to mount up onto the ridge of the roof, and there, facing northward and stretching out the clothing, to call out three times in a loud voice, "Ho, such a One! Come Back!" Then he is to hand the clothing down from the front eaves to another below, who is to receive it into a box and carry it therein into the house, entering by way of the eastern steps. And this other one, going into the room where the deceased lies, is to lay the clothing down upon the corpse. The summoner, meanwhile, is to descend from the roof by the west end of the rear eaves.

A far more persuasive plea than the perfunctory lines from the *Yili* comes from a poem attributed to Qu Yuan. Qu Yuan was a virtuous Chu minister who was slandered and banished from service by King Huai (r. 328-299 B.C.). He is said to be the author of the poems collected and assembled in the Han dynasty as the *Chuci*, from which this excerpt is taken.

> O soul come back! Why have you left your old
>
> > abode and fled to the earth's far corners,
>
> Deserting the place of your delight to meet all those
>
> > things of evil omen?
>
> O soul come back! In the east you cannot abide.
>
> There are giants there a thousand fathoms tall, who
>
> > seek only for souls to catch,
>
> The ten suns that come out together, melting metal,
>
> > dissolving stone
>
> The folk that live there can bear it, but you, soul,
>
> > would be consumed.
>
> O soul, come back! In the east you cannot abide.

And so it goes for the south, west, north, up, and down, first instilling fear and then drawing the soul back to its pleasures.

If the shaman or soul-summoner succeeded, the *hun*-soul was restored to the body, and the person "cured." If not, formal funeral preparations began, with explicit instructions not to use the garment that had stood as proxy for the body in the summoning exercise. The corpse was moved from its place on the ground in the northern part of the mourning hall and laid out on a couch in the south, a movement from the dark *yin* north to the bright *yang* south. The funeral rites were then carried out to care for the body and the second soul, the *po*-soul, which remained with the body in death.

The deceased would then receive ritual offerings-meat and wine in various vessels placed beside him. The death was then announced to the people outside the hall. Clothes to dress the body were brought by relatives paying their condolences, and the body was prepared for burial by dressing it in several layers. Pl. 89

Following the laying out and dressing of the corpse, the *bin* ceremony took place outside the mourning hall. A shallow pit was prepared, and the coffin lowered into it, and then the body was placed in the coffin. In this temporary grave, the deceased was again mourned by friends and relatives. A banner

1 Wu Hung, "Art and Architecture of the Warring States Period," in Loewe and Shaughnessy, *The Cambridge History of Ancient China*, 726ff. See also his essay, "Beyond the Great Boundary," in John Hay, ed., *Boundaries in China* (London: Reaktion Books), 1994.

Qu Yuan (ca. 340-ca. 278 B.C.) was born in Zigui, in what is now Hubei Province, into an aristocratic family of the same surname as the feudal lord of Chu. He was the first great poet in Chinese literature, and his poetry is characteristic of Chu culture and style. Before Qu Yuan, Chinese poems and songs were short and anonymous. In his poetry, he recreated the local folklore; vividly depicted shamanistic worship to summon and appease the spirits; wrote showy miniature operas portraying the luxurious life at the palace; deeply detested the political corruption; and sadly recorded a picture of people's suffering. His depiction of hardships and observations of common people in remote regions help contemporary readers to understand the situation and tribal customs of the Chu culture in the Warring States period. His poetry clearly reflects the history, cultural background, prevalent superstitious beliefs, and shamanistic practices in the world of his time

Qu Yuan was an erudite scholar and talented politician with a retentive memory. During the reign of King Huai, he worked at the Chu court with the rank of minister. He discussed national affairs with the king and received envoys from other states, including Qin and Qi, the most powerful states in this time. He was also sent to visit other states as far away as Qi. The king of Chu entrusted this young politician with heavy responsibilities. Soon Qu Yuan was defamed by jealous and corrupt high officials. During his lifetime, he was exiled twice-first toward the end of Huai's reign, and again toward the beginning of the reign of King Qingxing

(298-263 B.C.). He finally committed suicide. He is remembered in China by the Dragon Boat Festival that occurs annually on the anniversary of his death.

The *Chuci* was compiled at the imperial library during the reign of Emperor Shun (r. A.D. 2nd century) of the Han dynasty. It is the earliest collection of poetry from the region of the Yangzi River and its tributaries, the Han and the Huai, understood generally as the region of Chu. The *Chuci* stands together with the *Shijing*, from northern China, as the earliest collections of Chinese poetry, each reflecting a different region and time. The two collections differ significantly in meter and sometimes in subject, but both were sung to music. The *Chuci* has a pulsating, nervous rhythm, based on lines of uneven length, two half-lines typically connected by a notation indicating that a breath was to be taken. The *Shijing*, on the other hand, is counted in a march-like four-beat meter. The *Chuci* appears to reflect the secularization of a more ancient oral tradition believed to derive from shamanistic rituals practiced throughout China during the Bronze Age, but frequently identified in literature and histories with the region of Chu. The *Chuci* exhibits such shamanistic features as invocations for the return of wandering souls and real and allegorical flights of persons across the earth and through the heavens, accompanied by natural and divine spirits.

Pl. 58

was inscribed with his name, and to this were added the names of visitors who paid their respects. After these ceremonies, the coffin was inserted into the outer coffins and carried to the tomb.

TOMB OF THE MARQUIS YI

The site of the tomb of the Marquis Yi is in northern Hubei Province, east of the Han River. There are many Spring and Autumn tombs in this area; 5th-

century-B.C. tombs are less common. Most 5th-century-B.C. tombs are found farther to the south, nearer to the Chu capital at Jiangling.

This tomb was discovered during the course of building a factory, and archaeologists were alerted to its existence only after the aboveground features of the burial, whatever they might have been, were erased. The presence or absence of a ramp or steps from the mouth of the trench would have been significant, if it

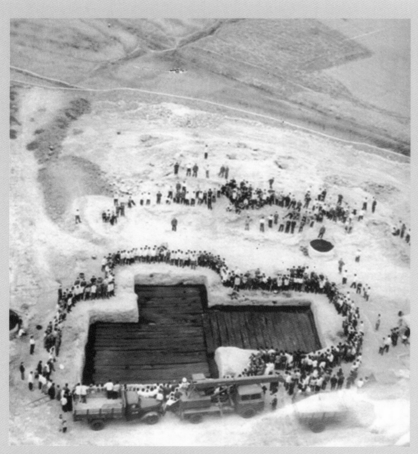

Aerial view of the tomb of the Marquis Yi

LAYOUT AND CONSTRUCTION OF THE TOMBS

The layout and construction of traditional Zhou and Chu tombs differed. Chu tombs were generally stepped into a vertical pit and approached by a ramp. The coffin chamber was in the center. The tomb of the Marquis Yi is laid out in adjacent "rooms," like a palace structure.

had been confirmed. Such ramps were common in the Chu region, but some scholars believe that they were restricted among the Zhou lineage to the Sons of Heaven. The absence of a ramp if confirmed, would support a link between the Marquis Yi and Zhou royalty. The shaft of the tomb was preserved; it is presumed to have once reached approximately thirteen meters below ground. The wooden tomb complex had been carefully sealed, first by a fill of charcoal pounded to a thickness of ten to thirty centimeters, and then by a layer of sticky, green clay.[2] The tomb chamber had been penetrated once by robbers, through a corner of the central chamber. The robbers left iron tools behind, and, seemingly, all of the contents of the tomb as well. When excavated, the tomb was filled with

water, but when the water entered the tomb is not known.

The tomb chambers were made of large catalpa timbers six to ten meters long and three meters high. Small openings at the base of the interior walls are thought to have served as passages within the structure. Wooden pegs were found in the walls, from which, it is supposed, curtains were hung.

The irregular plan of the Marquis Yi's tomb, as well as its size, is unusual. Most late Zhou burial chambers were nested coffins within a central chamber surrounded symmetrically by four chambers containing grave goods. Yi's tomb was laid out like a dwelling place, with rooms for different uses.

The rectangular central chamber was furnished with the appointments of the ceremonial hall of a palace. Ritual vessels were arranged in rows along the south wall of this chamber, and the monumental bells and other ritual musical instruments were housed here.

Pls. 17 19, 20 21

2 Robert L. Thorp, "The Sui Xian Tomb: Re-thinking the Fifth Century," *Artibus Asiae* 43, no. 5 (1981): 67-92.

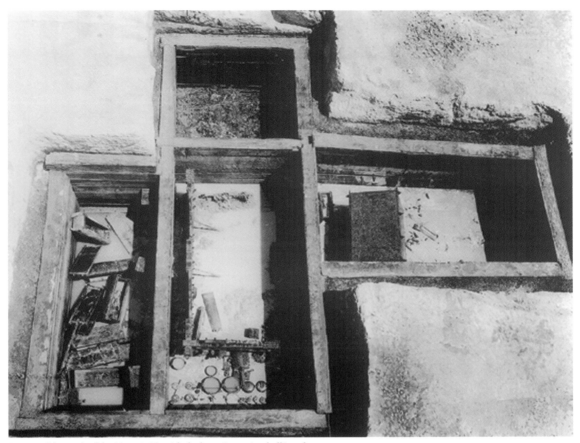

Layout of the tomb of the Marquis Yi, with the large "reception hall" at the center

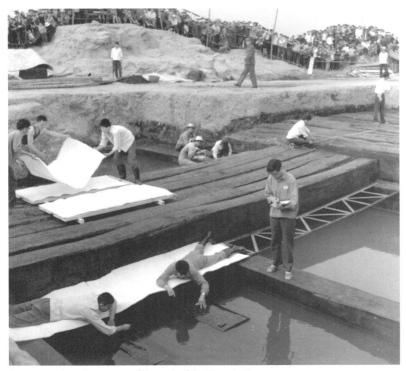

Excavating the infrastructure of the tomb of the Marquis Yi

BAMBOO SLIPS WITH INK WRITINGS

There were 240 bamboo slips uncovered in the north chamber of the tomb of the Marquis Yi. These slips-with black ink on the bamboo surface-are early examples of brush writing.

When made-in an age predating the invention of paper-these bamboo strips would have been strung with two lines of cords and used as a paged book. Some of the ink characters were so blurred as to be illegible.

The 6,699 characters on the slips have been studied by Chinese etymologists and annotated by these scholars. All the characters were written in greater seal script (which predated the uniform style developed in the Qin dynasty). There were varied forms of the greater seal script in the feudal states. Even the Chinese of the Han dynasty found it difficult to interpret the writings in greater seal script, as the script type had evolved so much in such a short amount of time.

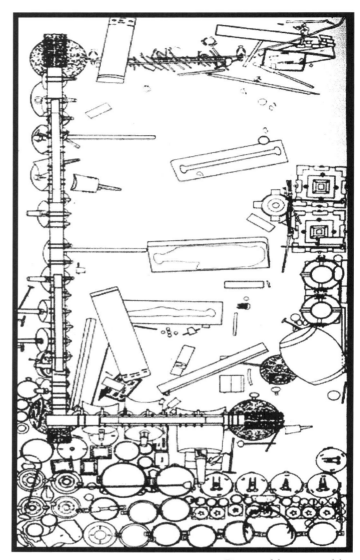

Diagram of the contents of the central chamber of the tomb of the Marquis Yi

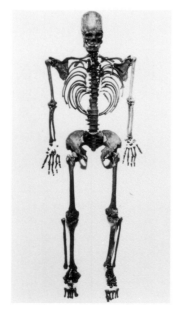

The skeletons of the Marquis Yi and his dog

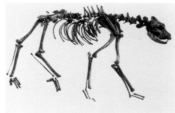

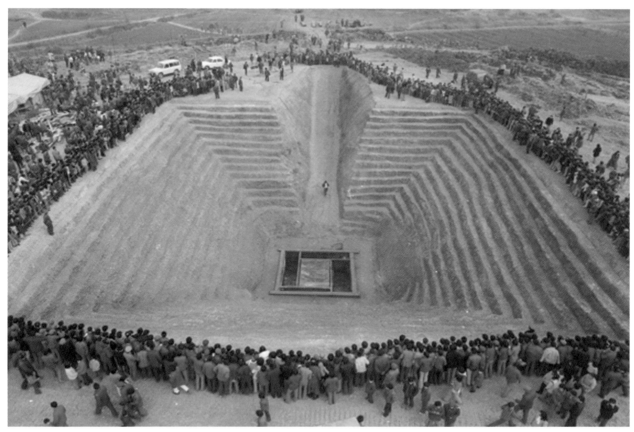

Tomb #2 at Baoshan

North of the central chamber was the armory, a square chamber containing over 4,500 shields, pieces of armor, and weapons, and more than 1,000 items related to horse and chariot fittings.

To the west of the central chamber, and parallel to it, was a room containing thirteen coffins, with the bodies of women between the ages of thirteen and twenty-six who accompanied the master in death.

The chamber containing his double coffin was east of the central chamber. It contained nine lesser coffins as well, one for a dog and the remaining eight for women presumed to be his concubines. In this chamber, musical instruments suited to singing and entertainments were also found.

It is significant that the tomb contained sacrificial victims. By the 5th century B.C., this was more common in tombs of the Chu region than in tombs of the Central Plain, where increasingly *mingqi* (spirit goods) in the form of humans and animals, in wood or ceramic, served the function once performed by flesh-and-blood humans and animals.

TOMB #2 AT BAOSHAN

This Baoshan tomb had four chambers around a central chamber. The grave goods were registered on twenty-one slips found in the tomb, distributed in compartments around the central chamber along with the goods they described. The east room was identified as the "food room" and contained bronze vessels and foodstuffs. The list in the west room identified that compartment as containing "objects that one uses when traveling." A lacquered picnic box was among Pl. 91 the objects found in the west room. Two lists were found in the south chamber, one identifying appointments for the *Dazhao* (Great Summons) ceremony held in front of the ancestral temple of the deceased before the entombment of his coffin, and the second enumerating the horses and chariots used in the funeral procession.[3] The Baoshan tomb differed in layout from the Marquis Yi's tomb in having side chambers around the central chamber, rather than an asymmetrical "palace" layout. It also had the typical Chu features of a ramp and stepped sides, which were lacking in Yi's tomb.

3 Wu Hung, "Art and Architecture of the Warring States Period," 726ff.

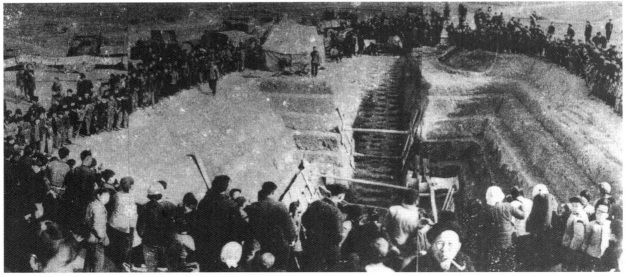

Tomb #1 at Wangshan

According to divination records sealed in Shao Tuo's tomb, he was diagnosed with "an illness in the abdomen and heartburn."[4]

TOMB #1 AT WANGSHAN

About seven kilometers from the Chu capital is a large cemetery. The first tomb was discovered in 1965, during a road building program. This grave was partially disturbed prior to excavation. The tomb is of typical Chu design-a vertical pit, narrowing to the tomb chamber. The stepped walls are tamped earth. Bronzes, lacquerware, textiles, earthenware, and bamboo slips were found in the tomb. The corpse was encased by two coffins, and the fragmentary remains of the skeleton indicate that the inhabitant was a male, approximately thirty-five years old. By the contents of the burial, the deceased is judged to have been a *daifu* (middle-ranking official).

THE FUNERAL PROCESSION

Objects from these three tombs suggest that a record of the the funeral procession itself was an important aspect of the individual's well-being in death. The quantity, quality, and propriety of the offerings to the deceased in the funeral rites reflected the moral and social standing of the deceased. The chariots and horses used in funeral processions, and their fittings

Pls. 79 80, 81

and trappings, were documents of the stature the deceased was accorded in life and his expectations for the continuing life in death. The beautifully crafted staff from Baoshan Tomb #2-recently restored-suggests that it was a prized personal possession or figured prominently in the deceased's funeral procession, or both.

Pl. 78

Other objects in the tomb seem designed to protect the deceased, and to confine him or her to a realm of comfort and ease. The afterworld was not a new world, nor a perfect one. It was a residence, within which life's accustomed rituals could be performed with propriety and one's needs for comfort and luxury met. The deceased, or his posthumous soul, would live in elaborate halls served by numerous attendants, surrounded by familiar objects. Life after death was seemingly viewed as secular, urbane-properly ordered by rite and provision.

Pl. 97

BURIAL AND CLASS

The burials that have yielded the objects in this exhibition were all reflections of the high station in life held by these deceased. Class in ancient China was expressed as rank in relationship to the Son of Heaven (in descending order):

Feudal lords	*zhuhou*
Ministers	*qing*
Senior officials	*daifu*
Knights	*shi*
Commoners	*shuren*

4 David Harper, "Warring States Natural Philosophy and Occult Thought," in Loewe and Shaughnessy, *The Cambridge History of Ancient China*, 855.

The inner and outer coffins of the Marquis Yi

RITUALS WITH FOOD AND WINE

Communication with the spirits through offerings of food and wine was a central part of rulership in the Shang dynasty. The correct performance of ritual offerings was a matter of concern to both individuals and the state, as the pleasure or displeasure of the spirits could influence events. Individual lineages participated in this universal order by performance of rites to their ancestors in the spirit world; these ancestral spirits, in turn, looked after the well-being and correctness of activities of the family. The medium of this communication was a banquet of food and wine prepared according to prescribed ritual actions in ritual vessels.

The Western Zhou continued to use Shang ritual vessel types, with progressive changes, but generally sets included predictable shapes with various styles of decoration. A dramatic change appeared in the 9th century B.C. Vessel sets now featured multiples of the same vessel, identical in shape and decoration, where before one had served. Sets became sets of sets. The size of objects and their corresponding weight grew

Rank was as least as important in death as in life, and its display was strictly regulated. From the *Xunzi* (ca. 298-38 B.C.):

> Hence the inner and outer coffins of the Son of Heaven consist of seven layers; those of the feudal lords consist of five layers, those of the high ministers, three layers; those of the officials, two layers. In addition, there are various rules governing the amount and quality of grave clothes and food offerings for each rank, and the type of coffin decorations and ornaments appropriate for each station, whereby reverence is expressed in outward form.

The Marquis Yi's burial, with its more than 10,000 objects in the most precious materials-bronze, jade, gold, lacquer, and iron-was lavish by any standard. The inclusion of a ceremonial hall with ritual vessels and musical instruments gave particular emphasis to the public role of ritual performances, and contributes to our understanding of the impressive display they offer.

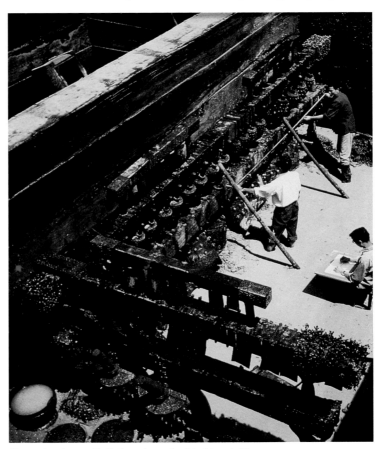

Excavating the set of bells from the tomb of the Marquis Yi

This exhibition features artifacts from the tomb of Marquis Yi of the state of Zeng. It was in his tomb that archaeologists discovered the most spectacular example of an orchestral collection of musical instruments from the 5th century B.C. Archaeologists recovered from the central chamber of the tomb a total of 125 musical instruments, including stringed instruments such as the *se* (zither) and *qin* (lute); wind instruments such as the *pai-xiao* (pan-pipes) and *sheng* (reed mouth-organ); and percussion instruments such as the *bian-zhong* (set-bells) and *bian-qing* (stone chimes). An early discussion of the principle of orchestral arrangement is found in the *Guoyu* (Discourses on the States) from the 5th century B.C.:

> Musical tones and their sympathetic sounds are said to be in harmony *(he)*, if they mutually support *(bao)* each other. Soft and loud tones are said to be in balance *(ping)* if one does not overtake *(yu)* the other.

The discovery of such an ensemble of musical instruments has greatly enhanced our understanding of the early history of Chinese musicology.

An early account of ancient Chinese music tells the story of Ling Lun, who went to the valley of Xie-Xi in search of perfect bamboo stems with uniform aperture and thickness for the standardization of the *Huang-zhong* (Yellow-bell) pitch. He then constructed, based on this pitch, a set of twelve-pitch pipes that harmonized perfectly with the singing of the *feng huang* birds. The ancient Chinese belief that there exists a universal pitch in harmony with nature is enshrined in this story. Music tuned to the universal pitch is perceived as the medium through which one communicates spiritually with one's inner

self and ancestors, as well as with nature and the supernatural.

One of the earliest extant descriptions of music is found in the *Shun Dian* (The Canon of Shun) section of the pre-Zhou dynasty *Shangshu* (The Book of Documents):

> Ode expresses thought in lyric,
> Song puts lyric in singing,
> Sound is produced to facilitate singing,
> Pitch is used to harmonize sound,
> **Ba-yin** are provided to enrich harmony.

Here the term *ba-yin* refers to the eight tone qualities, which are identified by the eight sound-producing materials:

jin (metal)	*tu* (clay)	*si* (silk)
pao (gourd)	*shi* (stone)	*ge* (skin)
mu (wood)	*zhu* (bamboo)	

In addition to the *ba-yin* classification of tone quality, the ancient Chinese also identified twelve varieties in tone quality coming from configurations of musical instruments as delineated in the *Zhouli*, which was compiled in the 2nd century B.C. Such interests in tone quality were undoubtedly responsible for the early practice of performing music with a number of musical instruments playing together, as evidenced by records found in the Zhou dynasty *Shijing*.

The musical instruments presented in this exhibition include replicas of the set of sixty-five bronze set-bells and

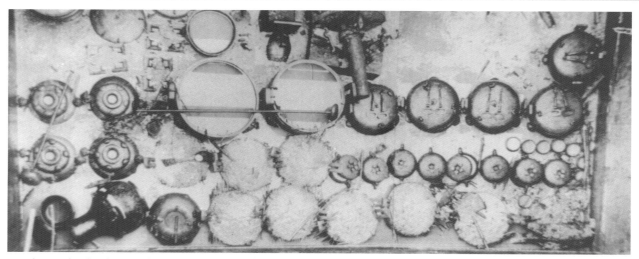

Vessel sets as found in the tomb of the Marquis Yi

the set of stone chimes that were found in Yi's tomb. This find is invaluable not only because of the tonal systems the instruments embody but also because of the inscriptions they bear. These inscriptions provide important information on ancient note names, pitch names, musical theories, and acoustic principles. They disclose not only the relationships between the pitch systems of the neighboring states, but also the influence of the Chu culture on the Zhou traditions of the state of Zeng. The pitch systems represented by the Marquis Yi's instruments provide an unprecedented opportunity for studying the parallel systems of nomenclature that existed in the period before the Qin dynasty.

The set-bells-each cast with an almond-shaped cross-section-are all two-tone bells. The two notes, usually a third apart, are produced by striking the bell at the *zheng gu* and *ce gu* strike points. Holographic studies of the vibrational behavior of such two-tone set-bells reveal, as expected, two distinct families of vibrational modes for each of the strike points. The measured frequencies of the strike notes of the set-bells unveil a chromatic structure for the musical scales covering a range of more than five octaves. In view of the fact that these bells were cast in the same century that the Greek, Philolaus, is said to have discovered the whole note and developed the diatonic intonation by subdividing tetrachords in an octave, this chromatic tonal system was a remarkable achievement in musicology and acoustics. The frequency measurement also reveals that the 5th-century-B.C. *Huang-zhong* pitch corresponds approximately to a frequency of 410.1 vibrations per second.

An important musical theory is the *xuan-gong* principle, which states that each note of a scale can in turn act as the fundamental, and so define a musical mode. Since each pitch can be used as a key to start the fundamental, the possession of a set of twelve pitches greatly enhanced the availability of mode-keys to the early Chinese musicians. The appreciation of the multiplicity of mode-keys is evident from a number of ancient Chinese records. We have from the 2nd-century-B.C. *Huai-Nan Zi* (The book of the Prince of Huai-Nan), for example, the statement of the multiplicity of pentatonic mode-keys:

One pitch generates a set of five notes.
Twelve pitches form a set of sixty notes.

In the ancient Chinese system of nomenclature for mode-keys, the *gong* mode in the *Huang-zhong* pitch, for example, is simply *Huang-zhong-gong*.

The development of chromatic scales was probably motivated in part by the early interest of Chinese musicians in modal variation and mode shifts in music, which is well documented in Chinese classics such as the *Lu-Shi Chun-Qiu* (Master Lu's Spring and Autumn Annals) and *Zuo Zhuan* (Master Zuoqiu's Commentary on the Spring and Autumn Annals).

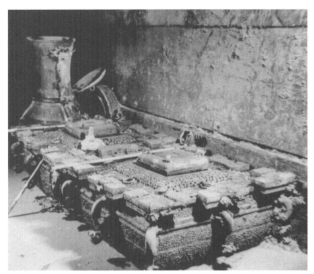

Ritual vessels from the tomb of the Marquis Yi

to massive proportions. So emphatic a change in the ritual implements must correspond to a change in the rituals themselves. Objects were too heavy to move, and the way they were used required gestures of a grand scale. They are awesome in their sheer physical presence and must have been designed to play to a larger audience than the smaller vessels of earlier periods.

Burials provide information about the use of bronze vessels in sets that had been lacking in the study of individual objects removed from their context. The Marquis Yi's tomb is one of the most informative for that reason.

VESSEL SETS
WANG JICHAO

The following chart illustrates at a glance the changes that were made in vessel types over time and across regions.[5]

Period	Central Plain	Regions of Chu Culture
early Spring and Autumn	ding, gui, hu, pan, yi	ding, gui (fu), hu, pan, yi
mid-Spring and Autumn	ding, gui, zhou, pan, yi	ding, fu, fou, pan, yi
late Spring and Autumn	ding, gui (dou), zhou (lei), pan, yi	ding, fu, fo, (dui), pan, yi
early Warring States	ding, dou, hu, pan, yi	ding, fu, dui, hu, pan, yi
mid-Warring States	ding, dou, hu, pan, yi	ding, dui, hu, pan, yi
late Warring States	ding, dui, hu	ding, he, hu, pan, yi

The *ding* remained unchanged as the centerpiece of a grouping of food, wine, and water vessels. The major alteration in the chart is the *combination* of food vessels. In the Central Plain, the combination of *ding* and *gui* was changed to *ding* and *te fu*, then to *ding* and *dui*, and finally to *ding* and *he*. The reason for such changes was based on the differences in food supplies between the south and the north. The combination of Chu ritual bronzes had two other important features: the round *ding* were arranged in even numbers on the altar, and the *fou*, the small-mouthed *ding*, and the *he* became significant aspects of the ceremony. These changes were probably related to the local custom as well as the climate-affected food supply. After the Chu people entered the Hubei region, they amalgamated with the indigenous cultures of Yue, Wu, Huei-Yi, and Ba-Shu. The Chu culture adapted and developed rapidly in accordance with its new environment.

5 For an illustrated chart of vessel types, see *Treasures from the Bronze Age of China* (New York: Metropolitan Museum of Art, 1980). Unfortunately, space does not allow for inclusion here.

SUMMARY VIEW OF THE DEVELOPMENT OF RITUAL BRONZES

The Shang dynasty represented the first golden age of the China's Bronze Age. The era is often referred to as the Yin-Shang period, as the Shang capital city was in Yin (present-day Anyang, Henan Province). Shang artisans produced bronze vessels in a wide variety of forms and with strong, appealing decoration. Animal masks cast in relief served as the dominant motifs on a background filled with tiny frets or spirals. Some of these animal masks even today convey an impression of awe and heroism.

Shang bronze utensils are generally classified into three categories. The first is cooking vessels, which include *ding, li,* and *yan* steamers. The second is food containers, which include *gui*. The third is wine vessels, which include *zun, you, hu, lei, yi, jia, jue, zhi, ku, he,* and *gong*. These vessels were used for sacrificial ceremonies, during banquets, as gifts to other states, and as funerary objects. The utensils used for daily living, eating, and drinking were made of pottery or wood, not bronze.

WESTERN ZHOU

The Shang dynasty was overthrown by Wu, the king of Zhou (one of the Shang feudal states) in the late 12th century B.C. The laws of the new Zhou dynasty followed the example set by the Shang, and maintained a political system of feudalism, with the distribution of fiefs to royal relatives and meritorious officials. The Zhou aristocrats inherited and maintained the Shang dynasty rites. In the early part of the Western Zhou, Zhou bronze vessels were close in style and decoration to late Shang vessels. But the production of ritual wine vessels decreased remarkably because the Zhou court was wary of the alcohol addiction that had characterized the Shang ruling class. To prevent this recurrence among its own members, the Zhou court issued extremely harsh punishments for Zhou subjects found to be drinking (but only issued a warning to offenders who were Shang descendants).[6] Several types of Shang wine vessels-*gu, jue, jiao, jia, zun, yu,* and *fang-yi*-all but disappeared by the middle of the Western Zhou dynasty.

6 The severe restrictions and warnings to alcoholics were recorded in the *Shujing* and were inscribed in 291 characters on the large *yu-ding* vase in the twenty-third year of the reign of King Kang (11th century B.C.), which is now in the collection of the Natural History Museum in Beijing. See Li Xueqin, "The Origins and Development of Chinese Bronzes," in *Collection of Chinese Fine Art: Bronze* (Beijing: Wen Wu Publications, 1985), 9, fig. 148. For a modern edition of the *Shujing*, see James Legge, *Shu Ching: Book of History* (Chicago: Henry Regnary, 1971), 153-57.

The Zhou bronze vessels began to depart stylistically from the Shang tradition. The shape of the food vessel called a *gui* (attached to a *jin* pedestal) presents the most noticeable change. The adding of large flanges to *ding, yu,* and *fang-yi* were minor changes. The common motifs of animal masks, *kuei* dragons, birds, and clouds-and-thunder persisted into the early Western Zhou.

An important change was the lengthening of inscriptions on Zhou vessels. These inscriptions are documents praising Zhou ancestors, achievements, and historical events. They provide primary source materials for contemporary scholars.

A major setback in the political history of the early Western Zhou was the death of King Zhao. Zhao, the fourth Zhou king, undertook an expedition to the south to attack Jing-Chu, but was drowned in the Han River. This accident weakened the peace and prosperity that the Zhou rulers had established.

From the middle of the Western Zhou, the authority of the royal court declined. This in turn enhanced the power of the feudal lords. These political developments are reflected in the changes in the cast bronzes. Decorative motifs became simpler, with a prevalent wavy-band design.

The splendidly decorated *yu* and *fang-yi* vessels became rare. Inscriptions were formalized into rigid patterns. Only the *zhong* bell was a new creation.[7]

Two significant events occurred during the late Western Zhou. In 841 B.C., the tyrant king Li was exiled by the Zhou to Zhi (modern-day Huo District in Shaanxi Province), and died there fourteen years later. During these years, the dukes Zhou and Zhao acted as regents, and the period is referred to as the Gonghe Regency. With the beginning of the regency, Zhou chronology can be established with confidence and accuracy. Once more, however, the unstable political situation was reflected in the field of bronze casting. Even as new shapes of food vessels emerged-the *xu, fu,* and *yi*-the metallurgy techniques dropped below previous standards.

The decoration on bronze vessels changed over the course of the mid- and late Western Zhou dynasty. In the first hundred years after the overthrow of the Shang dynasty, the legendary dragon motifs and mystical animal masks still followed the Shang style and dominated the decoration of bronze vessels. From the middle of the Zhou, however, these motifs dissolved into abstract patterns, such as the broad bands of wavy patterns that were derived from the curved body of the dragon motif. The coiling *kuei* dragon designs were transfigured into the curved and hooked forms of the *qiequ wen* (intertwined dragon motif). The scales of snakes and dragons became a doubling-ring pattern.

In the late Western Zhou, the decorations lost their mysterious vigor. This decline came about for two reasons. First, the Zhou aristocrats wanted their vessels to have simpler or plainer surfaces so that they could accommodate longer inscriptions. Second, the Zhou seem to have invested less import in their vessels than their Shang predecessors and the spiritual significance of the decoration lost its importance.

The political corruption during the reign of King You (781-771 B.C.) caused social turmoil within the kingdom, and eventually cost him his life, as the internal confusion invited an invasion by the Rong tribal people from the west. The capital of Haojing was ruined. The next Zhou king, Ping, had to move his people east.

THE SECOND GOLDEN PERIOD IN CHINA'S BRONZE AGE CULTURE

The Eastern Zhou, which begins with this move east, is divided into two periods-the Spring and Autumn period and the Warring States period. The term "Spring and Autumn" was coined by the book *Annals of the State of Lu.*

During the Spring and Autumn period, the power of the Zhou court declined, but the feudal system maintained the state as a whole. The reins of government were actually held by the aristocrats of each feudal state. Twelve bronze vessels in this exhibition belong to this period, and reveal the influence of the Zhou ritual bronze style.

Pls. 24 25, 32 34, 35 36, 41 46, 49 51, 52 56

During the Warring States period, the Zhou court was no longer respected by any state, and the feudal system gradually collapsed. Large-scale brutal wars were waged endlessly between various states, earning the period its name. The major portion of objects in this exhibition belong to this period, and bear characteristically Chu features.

7 Li Xueqin, "The Origins and Development of Chinese Bronzes," 9. Jessica Rawson is studying the changes in ritual as can be determined through changes in vessels. See her article in *Court and State: Ritual in China* (forthcoming).

*Diagrams adapted from Jessica Rawson, ed., **The British Museum Book of Chinese Art***

THE SETS IN THE TOMB OF THE MARQUIS YI

The diagrams above show that the Marquis Yi burial set consisted of:

*Two **hu** on a tray*
Two large jars
Two square hu in square buckets
One ladle
*One **pan-zun** set*
*Two large **huo ding***
*Nine **sheng ding***
*Five matched, covered **ding***
*Four unmatched, covered **ding***
*One large **li***
*Nine small **li***
*Eight matched, covered **gui***
*Four **fu***
Ten cups
*Three **dou***

Two boxes
One covered jar
*One **yan***
*Four **fu***
Two covered basins
*One narrow-necked **ding***
*Two **hu** with chains*
*One **pan***
*Three unmatched **yi** (one with a chain)*
*Two **pan** with chains*
Two shovels
Two incense burners

The set of nine *ding* found in Yi's tomb indicates that he was a feudal lord.

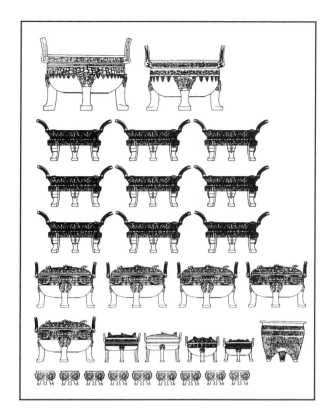

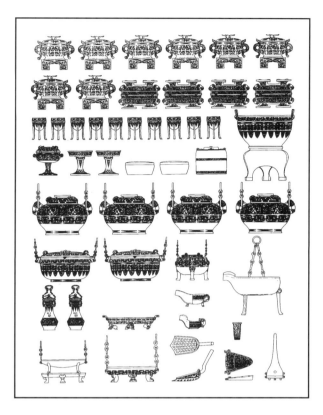

SOME IMPORTANT VESSEL TYPES

Ding (meat cooking and serving vessel)

Types of *ding* were distinguished by their ritual function. A *huo ding* was a large cooking vessel used, according to the *Liji,* for "boiling meat, fish, and dried meat." When the *hou ding* was excavated from the Marquis Yi's tomb, it contained a piece of ox bone, and traces of ash were seen on the bottom of the vessel. A *sheng ding* was a vessel for serving the meat that had been cooked in the larger *huo ding*. The *xiu ding*, or subsidiary *ding,* also contained remains of ox bone and had been used in cooking. Three small oxen decorate the cover. Even these subsidiary vessels were lavish; weighing almost thirty kilos and inlaid with turquoise.

Gui (grain cooking vessel)

Zhou regulations required that an odd number of *gui* be used with an even number of *ding* during sacrifices and banquets. Grain was served in *gui*. The footed *gui* was developed during the early Western Zhou, and its form was essentially preserved in the Warring States examples. The turquoise inlay that once defined the curvilinear pattern of the vessel lid and belly have since fallen out, perhaps because of the wet conditions in the tomb.

Hu (wine storage vessel)

Among the wine and water vessels, the two *hu* on a single platform stand out not only because of their massive size (99 cm) and weight (240 kg) but because they can still be seen as they were meant to be presented, side by side on a single low alter. The form of the vessel-a low-slung belly, a wide lip, large serpentine handles, and a strapwork-like division of the surface into eight sections-was known from metropolitan Chinese examples. But the size of this *hu* is remarkable, even for the Warring States period, when the size of vessels generally increased. No vessels better express the changed nature of ritual performance joined to the Western Zhou reforms than these *hu*.

In the later Warring States period, the *hu* was altered in shape, often squared in reference to lacquer vessels with wooden cores. Lacquer proved to be a medium more amenable than bronze to fluid and curvilinear lines, and the quantity of bronze used in a vessel gradually ceased to be a means of measuring the ostentatiousness of the display. Conversely, as the use of bronze declined, lacquer vessels assumed more important roles as ritual paraphernalia, further confounding distinctions between ritual and secular occasions.

Pan-zun (wine set)

The placement in the tomb of a *zun* (wine container) within a *pan* (tray) suggests two possible uses. The use of the *zun* is made clear by traces of wine, made from fragrant herbs, found inside. Large *pan* were traditionally used in metropolitan Zhou rituals to hold water for ablutions, but the obvious pairing in manufacture with a *zun* points toward a second function, identified in a passage from the *Liji*, "A tray holding ice is used at important funerals." The second function is supported by a comparison between this set and a set found in the tomb of Cai Zhaohou in Shouxian, Anhui Province. The Cai Zhaohou basin was inscribed with a glyph, *you*, that was used to denote wine. The southeastern style of this set may be a form of homage to the household to which it was going, as a part of a Cai princess's dowry.[8]

Pl. 47 Yi's *pan-zun* had a combined weight of over thirty kilos of bronze. The *zun* has thirty-four separate parts, and the *pan* thirty-eight. These were joined by casting or welding, and some were attached with prongs extending into the vessel. The openwork filigree, billowing like so much sea foam around the lip of the *zun* and growing like so much groundcover over the edges of the *pan* supported by filigree tigers, is a wonder of design and ingenuity. It is more of more in every way. The beholder was meant to delight in the dissolution of form into decorative assembly, and to marvel as the sheer impossibility of it all in bronze.

This aesthetic was pursued to the extreme of this *pan-zun* by the use of the lost wax method of casting. A liquifiable model was necessary for the three dimensional openwork filigree. The method was clearly known to Chinese craftsmen during this period, but it was generally abandoned after the desire to achieve these effects passed.

Jian (basin)

Pl. 48 Another remarkable kind of vessel from the Marquis Yi's tomb is a pair of massive square *jian* basins containing squared *fou* wine containers. The *jian* has eight attached dragon handles, and the square forms and blocks of filigree suggest wood-carving prototypes. The square wine container has a baluster body and four loop handles on the cover.

8 Colin Mackenzie, "Chu Bronze Work," In Lawton, *New Perspectives on Chu Culture*, 122.

The use of the *jian-fou* was to maintain wine at the appropriate temperature. The *jian* was filled with ice in the summer to cool the wine, and with hot water in the winter to warm it. To one familiar with summer temperatures in Hubei Province, it is easy to appreciate the design of this vessel and the appeal of the shaman's reminder of "Ice-cooled liquor, strained of impurities, clear wine, cool and refreshing."

DECORATIVE STYLES IN BRONZES

The metropolitan Zhou vocabulary of decorative motifs changed dramatically during the Eastern Zhou period. Western Zhou decorative styles, based on patterned remnants of Shang dragons, produced orderly undulants in low relief on the surface of a vessel. The use of pattern blocks in cast decoration permitted larger production of vessels with densely patterned surfaces, and a new style emerged. During the 7th and 6th centuries B.C., interlace began to appear to enliven what remained an essentially linear design. A stunningly rich metropolitan style of interlace emerged in the late 6th and early 5th centuries B.C., found in sites as distant as Liyu, in Shanxi Province, on China's northern border. This interlace became increasingly three-dimensional in products from the Chu region, as can be seen in the objects from the tomb of the Marquis Yi.

Interlace and inlay were two popular styles of Chu decoration, as evidenced by the finds in tombs of this region. They each satisfied a taste for dense visual excitement and intricate surface play. Both were simultaneously an affirmation and a denial of three-dimensionality.

Interlace

Extraordinary examples of interlace in bronze, lacquer, painting, and jade display the artisan's skill in giving depth to a surface with line, of seeing past one dimension to another, and of witnessing form in transformation. The graceful curling interlace of the interior and exterior of the bronze *nao* bell relaxes pattern into a sea of overlapping curls. Southern artisans exploited the literal three-dimensional potential of interlace, lifting curls, horns, and tongues off the surface, allowing their direction to resolve in space. The most vivid examples of this stylistic impulse are the base supporting the frame for the bells, in which raised elements

Pls. 4 17, 58 67, 86 95

Pl. 19

Pl. 17

Geometry underlying Celtic spirals and knotwork similar to Chu three-part spirals and joined knots (adapted from George Bain, **Elementary Methods of Construction**)

Pl. 23 were kept tightly curled against the body of the stand, and the drumstand for the shafted drum, in which all bonds were freed.

 Warring States interlace shares with Celtic interlace the morphing of line into fantastic animals, as well as elements such as plaiting, spirals, and key patterns. All such patterns are the result of variations on

Pls. 35 89, 94 95 connecting points within a grid. In this way, they are common to pattern-making in textiles, with its matrix of axes, up and down, right and left, and under and over. There is both a structural as well as an aesthetic kinship between woven textile patterning and the patterns developed for treatment of surfaces in other media. Rhythm, syncopation, theme, and variation, are aesthetic means underlying the vitality of pattern, and they are highly developed in Warring States period art.

Inlay

Inlay appeared as a popular style in the 6th century B.C. with early examples primarily in copper.[8] Later, colored inlay became more prevalent. Depressions were cast into the bronze to receive material such as copper, turquoise, gold, and colored pastes (in contrast to the common practice in western Asia of cold-working metal). As much of the inlay is now lost from vessels, we must imagine the bronze as a gleaming ground traced with colored designs. In some cases, the bronze became the form and the inlay the ground. A superb example of inlay in the exhibition is the covered wine vessel from Wangshan Tomb #1. Complex patterns in silver play around the sides of the vessel with all the fluency of painting.

Pls. 1 29, 34 35, 39 44, 54 55, 59 78, 82

See Jenny So, "The Inlaid Bronzes of the Warring States Period," in *The Great Bronze Age of China* (New York: Alfred A. Knopf, 1980), 305ff.

ASTROLOGY AND ASTRONOMY IN ANCIENT CHINA

JOSEPH C. Y. CHEN

Pl. 88

Two centuries of controversy among historians of science about the antiquity of a fully developed twenty-eight *xiu* star-groups system along the equatorial belt have been set to rest by the discovery of the 5th-century-B.C. astronomical diagram in the tomb of the Marquis Yi. The diagram was painted in red, with a black background, on the cover of a wooden chest. In the diagram, the names of all of the twenty-eight *xiu* star-groups are written clockwise in an oval ring, encircling the character *Dou* (Ursa Major). On opposite sides of the ring, a dragon and tiger denote the *Qing-Long* (Blue-Dragon) palace of the east star division and the *Bai-Hu* (White-Tiger) palace of the west star division.

At the second *xiu* star-group in the ring, *Kang*, the character for the date *jia yin* probably records the death of the Marquis Yi, indicating that he may have died on the third day of the fifth month, when the sun was in the *Kang* star group. This corresponds approximately to spring 433 B.C.

The appearance of the Blue-Dragon and White-Tiger star divisions in the diagram is of interest. Below is a comparison of this diagram with the burial layout of a tomb excavated in 1987 at Puyang, Henan Province. This tomb dates to the Yangshao cultural stratum of about 3000 B.C.

The images of the dragon and the tiger along the sides of the male skeleton (oriented toward the south) were made of shells. The similarity between the diagram on the chest and the burial configuration suggest that the ritual practice of celestial alignment had its roots in ancient mythology and that the Blue-Dragon and White-Tiger divisions have very early beginnings.

The Chinese *xiu* star-groups originated in tracing the apparent motion of the sun in relation to the seasons. According to the *Yao Dian* (The Canon of Yao):

- the day of medium length and the culmination of the star *Niao* (Hydrea) serve to adjust the middle of spring;
- the day of greatest length and the culmination of the star *Huo* (Scorpii) serve to fix the middle of summer;
- the night of medium length and the culmination of the star *Xu* (Aquarii) serve to adjust the middle of autumn; and
- the night of greatest length and the culmination of the star *Mao* (Taurii) serve to fix the middle of winter.

Over the course of time, twenty-eight *xiu* star-groups along the equatorial belt were identified and named. The character *xiu* means literally a resting place, and was coined to represent the mental picture of the identified star-groups as the resting places for the sun along its "journey."

The *xiu* star-groups also served as convenient references to specify celestial positions in recording celestial events. Examples of such usage are found as early as among the shell-bone inscriptions, made even before the set of twenty-eight *xiu* was complete. The oldest extant record of the sighting of a nova, dating to around 1300 B.C., reads, "On the seventh day *(ji-si)* of the month, a great star appeared in company with *Huo*." Here, the position of the nova, or *xin-xing*, is specified using the star *Huo*. Such a usage of *xiu* star-groups led eventually to the development of the celestial coordinate system of twenty-eight *xiu* (each identified by a determinative star) among the *chi-dao* (celestial equator) as one of the reference circles.

By the 4th century B.C., astronomers Shi Shen (of the Wei state) and Gan De (of the Qi state), began to list stars using the hour-circle and the equator-circle as the reference circles. In such a celestial coordinate system, the position of a celestial object is specified by the *qu-ji-du* (the distance from the north pole in degrees) and the *ru-xiu-du* (the distance in degrees to the determinative star of the nearest *xiu* in the correct ascension). It is well known that ancient Greek and medieval European astronomers used the elliptic and the circle of the celestial longitude as their reference circles. Not until the 16th century A.D., did the equatorial system begin to emerge as the major celestial coordinate system in Europe. In modern astronomy, a celestial position is specified by the declination in the hour-circle and the right ascension with respect to the vernal equinox on the equator-circle.

THE BODY IN DEATH AND THE AFTERLIFE

Burials combined articles taken directly from the world of the living with replicas and representations made specifically for burial. One kind of thing taken from life into the afterlife was human beings as companions and servants. In the Marquis Yi's burial, eight young women and a dog were buried in coffins of their own and entombed with their master. In a chamber on the ritual side of the ceremonial hall, thirteen other women (presumed to be servants) were buried. It was common for human sacrifices to be placed near the deceased. Different categories of sacrificial victim are identified in grave inventories. There are those "accompanying their master to the grave," and there are "dead servants." Members of the former were sometimes given members of the latter for their own use.

The practice of human sacrifice underwent changes during the Warring States period, along with the creation of spirit goods for use only in burial. In the Baoshan Tomb #2, two figurines more than a meter tall were carved in wood and dressed in silks. They were given real hair for braids and mustaches. In the early Warring States period, few southern burials contained replica figures; the number increased in the 3rd century B.C. There were growing moral sanctions against human sacrifices, and a growing belief that spirit goods could function effectively for the deceased in the afterlife.

Pl. 89 Confined to a coffin, the body of the deceased was dressed in several layers of garments, and given others in reserve. Archaeological finds have provided a great deal of information on how jade was placed on the body for ornament and protection.

Pl. 60 The body of the Marquis Yi was covered in several jade objects. A long pendant was found near his head; it would seem to have been hung from a headdress. Linked by three oval rings and a pin, the piece was carved from five pieces of jade into sixteen movable parts. The pendant is a veritable sampler of Warring States motifs-dragons, openwork, grain patterns, and borders of spiral line. The resistant medium bent to the artisans' insistent demand for surface interest.

Pls. 64 On the breast were laid ornaments such as jade dragons and pendants in *huang* and *pei* shapes. The 75 array of patterned pieces of jade was eventually linked into a complete jade suit in the Western Han period.

At the waist were small jade and gold garment hooks. Such personal objects became a focus for

SILK
WANG JICHAO

Embroidery and brocade developed in the culture of the Central Plain during the Western Zhou dynasty, and then were further refined. The techniques for weaving silk fabric developed rapidly after the mid-Warring States period. Over two hundred pieces of silk fabrics were found and categorized. It is extremely rare for fabric to survive over thousands of years, and so the stores of fabrics that have been discovered in the tombs from this area and time are to be prized both for their rarity, and for the quality of preservation that has enabled scholars to appreciate the extremely high levels of technical ability that had been achieved.

Motifs found in the silk weaving include geometric patterns, animal motifs (especially dragons and phoenixes), narrative depictions of daily life, and representations of religious exercises and practices.

ornament and an expression of status. Hooks have been found near the head of the deceased and were perhaps used to fasten headdresses. Other small hooks were Pls. 71 probably supporters for knives, swords, pouches, or 72 other paraphernalia at the waist. Although it has been suggested that the belt hook was introduced from the steppes during the Warring States period, actual belt hooks, some dating from the Spring and Autumn period, have been excavated mainly in Chinese contexts. Houma, in the area formerly covered by the state of Jin, has yielded numerous molds for casting belt hooks.

It is believed that the practice is based on the notion that if the orifices of the deceased could be sealed the body could be protected by the talismanic properties of jade. Yi held two jade plugs in his hands.

The high quality of some of the 5th-century-B.C. jade carving-with its intricate rounded forms and Pls. 58 imaginative designs-is not found in the later tombs 68, 70 from which objects were drawn for this exhibition. 92, 93 Those jade artisans seem to have been content to draw on the surface. In the later tombs, the focus of artistic energy shifted to lavishly painted lacquers and the arts of the brush.

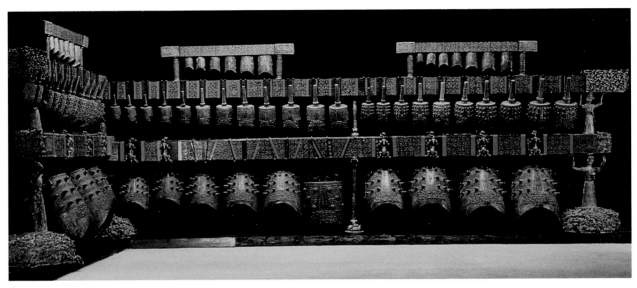

a

Plate 17

SET OF SIXTY-FIVE BELLS FROM SUIXIAN TOMB #1 (REPLICA IN EXHIBITION)
20th century
Bronze, inlaid with gold and copper, 273 x 746 x 335 cm

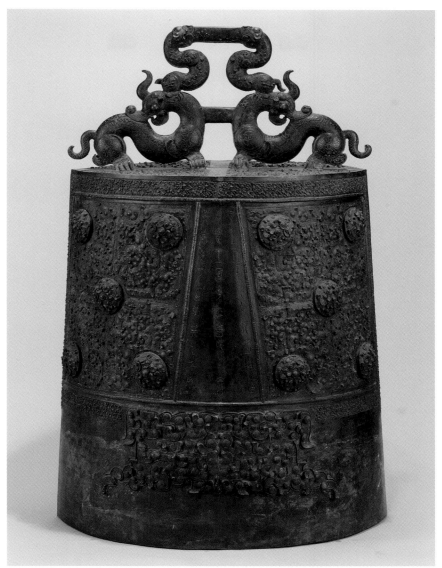

b

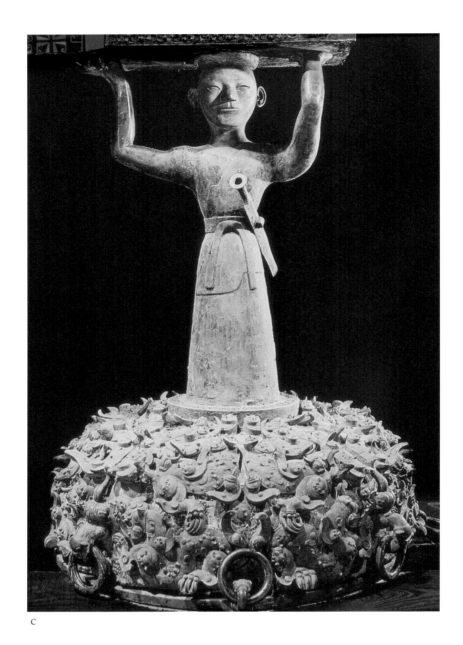

c

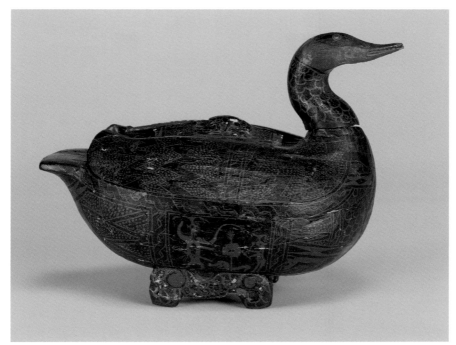

a

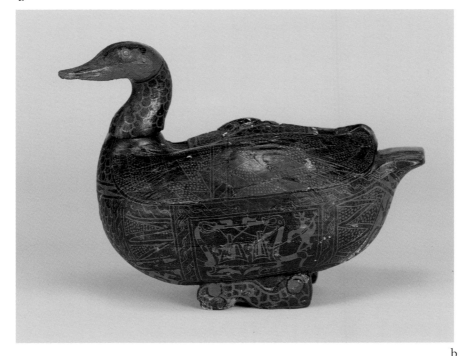

b

Plate 18

漆鴛鴦盒

DUCK BOX FROM SUIXIAN TOMB #1

5th century B.C., Early Warring States period
Painted lacquer over wood, 16.5 x 20.1 x 12.5 cm

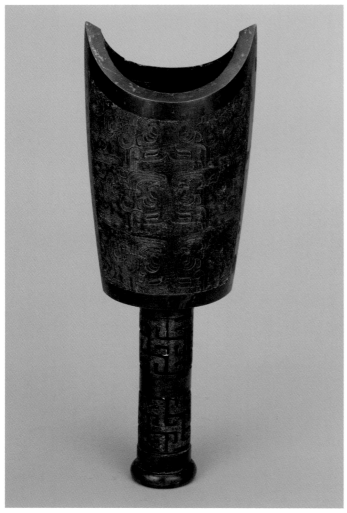

a

Plate 19

銅鐃
BELL FROM BAOSHAN TOMB #2
4th century B.C., Late Warring States period
Bronze, 27.5 x 11.5 cm

b

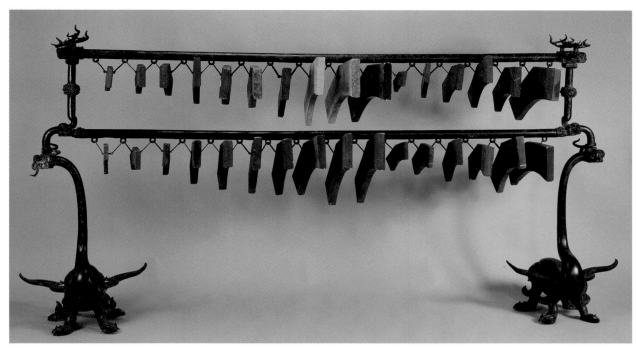

a

Plate 20

曾侯乙編磬

**SET OF THIRTY-TWO CHIMES
FROM SUIXIAN TOMB #1
(REPLICA IN EXHIBITION)**
20th century
Bronze and stone, 109 x 215 cm

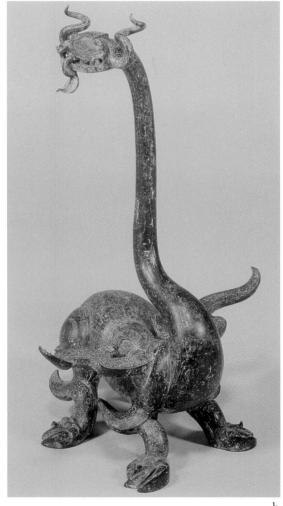

b

59

a

b

Plate 21

彩繪石編磬

CHIMESTONES FROM JIANGLING TOMB
5th century B.C., Early Warring States period
Stone, varied dimensions

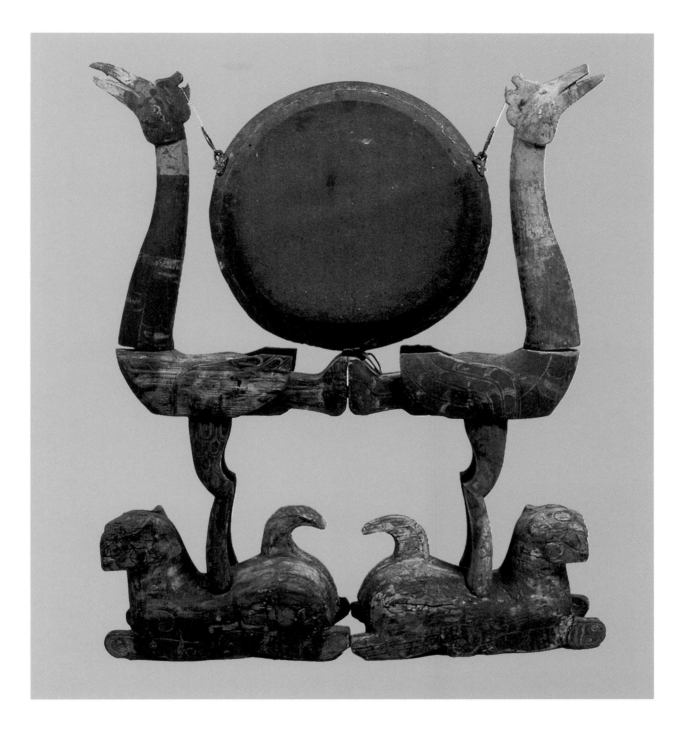

Plate 22

漆虎座鳥架鼓

DRUM STAND FROM WANGSHAN TOMB #1 (WITH REPLICA DRUM)
4th century B.C., Middle Warring States period
Painted lacquer over wood, 104 cm

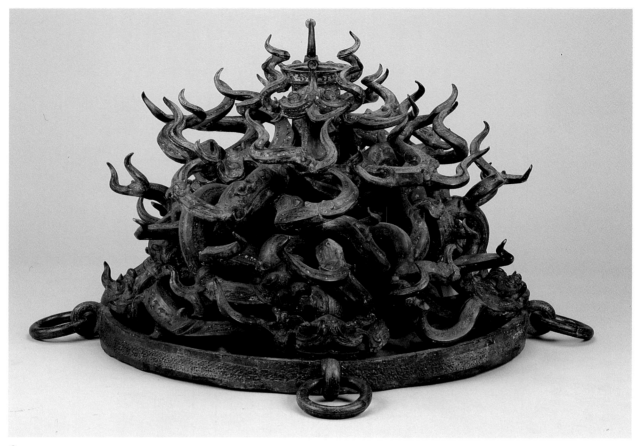

a

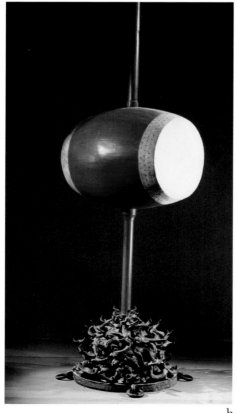

b

Plate 23

銅建鼓座

**DRUM STAND
FROM SUIXIAN TOMB #1**
5th century B.C., Early Warring States period
Bronze inlaid with turquoise, 54 x 80 cm

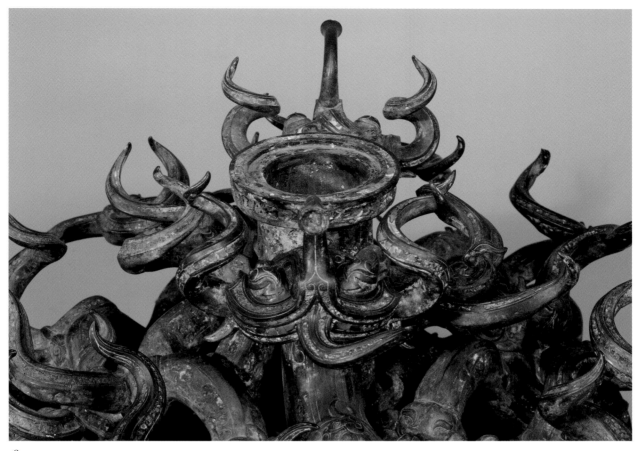

c

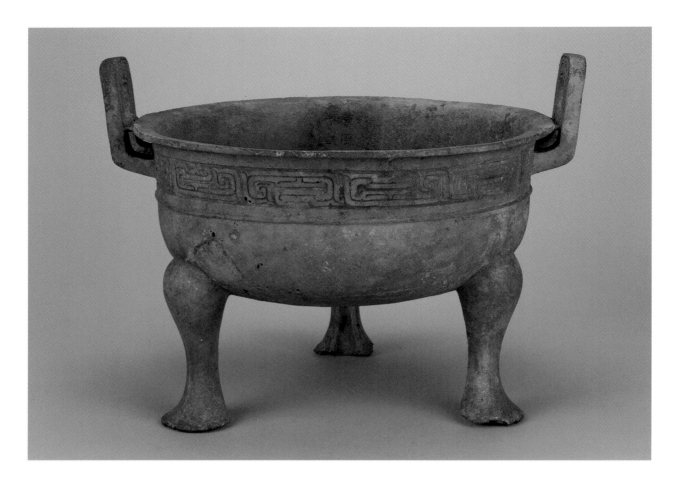

Plate 24

曾侯仲子斿父銅鼎

FOOD VESSEL FROM SUJIALONG TOMB
8th–7th century B.C., Early Spring and Autumn period
Bronze, 32.7 x 38.5 cm

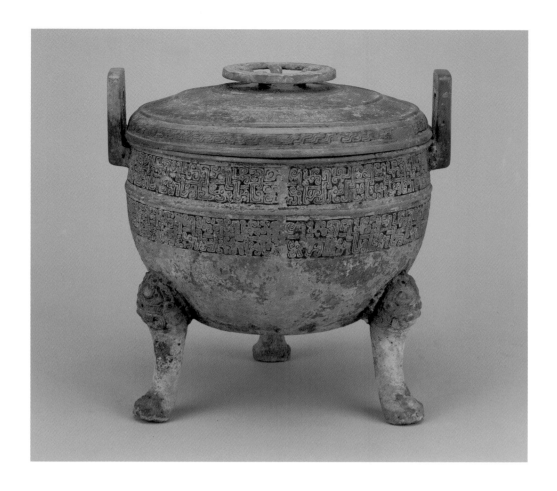

Plate 25

鄧公乘銅鼎

FOOD VESSEL FROM XIONGYANG SHANWAN TOMB
8th–7th century B.C., Early Spring and Autumn period
Bronze, 26.6 x 21.4 cm

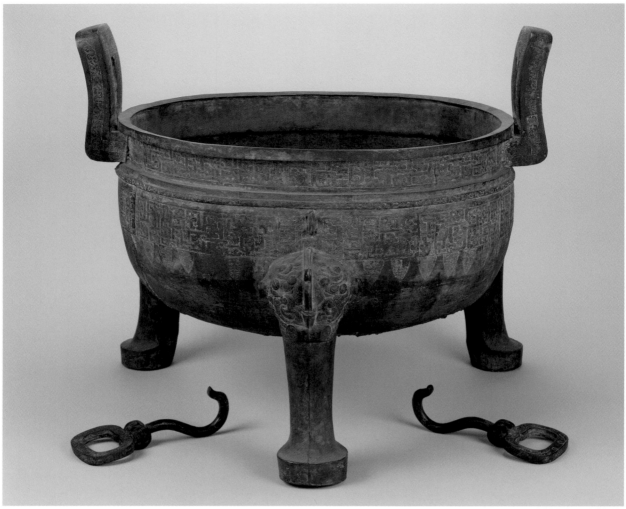

a

b

Plate 26

大鼎（附鼎鉤２）

**COOKING VESSEL WITH
TWO SUSPENSION HOOKS
FROM SUIXIAN TOMB #1**
5th century B.C., Early Warring States period
Bronze, varied dimensions

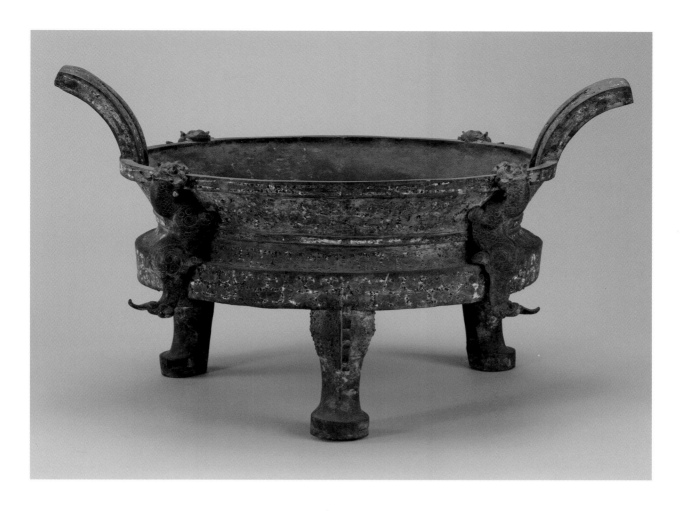

Plate 27

束腰大平底鼎
FOOD VESSEL FROM SUIXIAN TOMB #1
5th century B.C., Early Warring States period
Bronze, varied dimensions

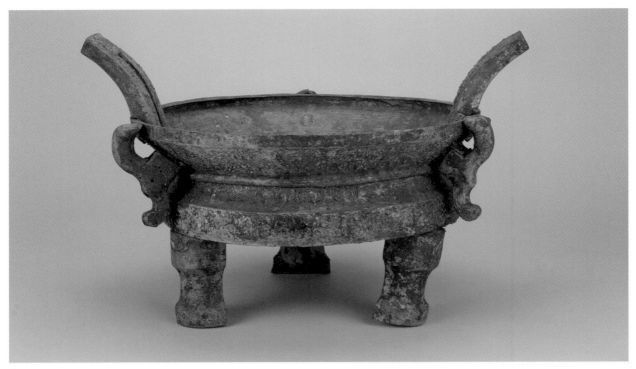

a

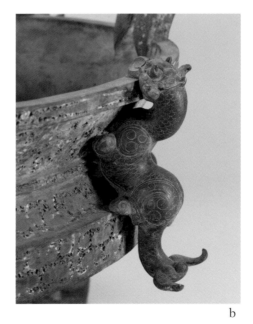

b

Plate 28

銅升鼎

FOOD VESSEL FROM BAOSHAN TOMB #2
4th century B.C., Late Warring States period
Bronze, 31.4 x 39 cm

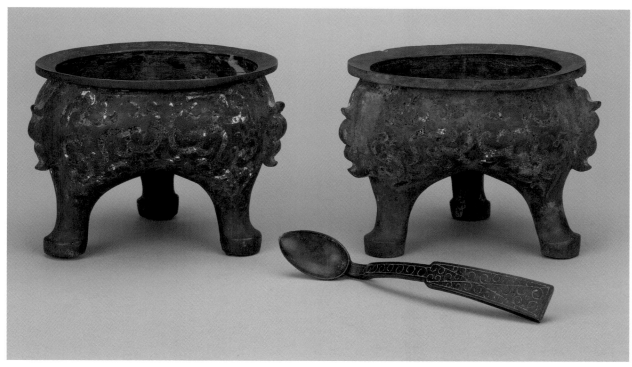

a

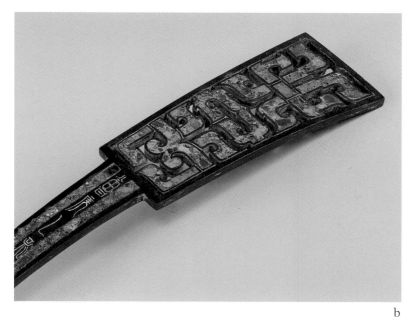

b

Plate 29

銅小鬲（附匕 1）

TWO FOOD VESSELS AND SPOON FROM SUIXIAN TOMB #1

5th century B.C., Early Warring States period
Bronze, varied dimensions

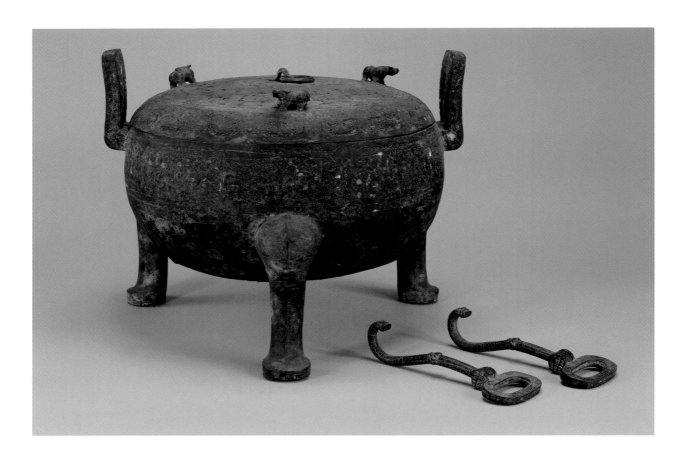

Plate 30

牛形紐蓋鼎（附鼎鉤2）

COVERED COOKING VESSEL WITH LID AND
TWO SUSPENSION HOOKS FROM SUIXIAN TOMB #1

5th century B.C., Early Warring States period
Bronze, 39.3 cm

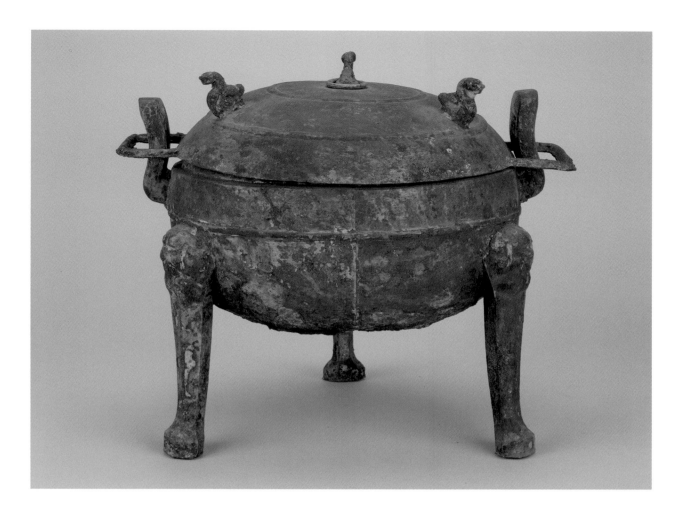

Plate 31

聏耳銅蓋鼎

COVERED FOOD VESSEL FROM BAOSHAN TOMB #2
4th century B.C., Late Warring States period
Bronze, 30 x 26.3 cm

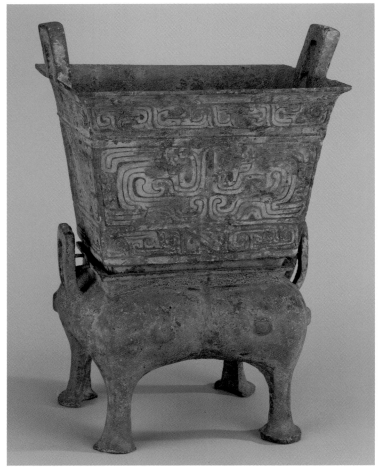

a

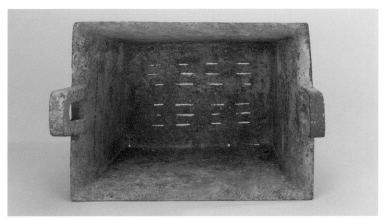

b

Plate 32

象首龍紋銅方甗

FOOD STEAMER FROM SUJIALONG TOMB
8th–7th century B.C., Early Spring and Autumn period
Bronze, 52 x 36 x 22.5 cm

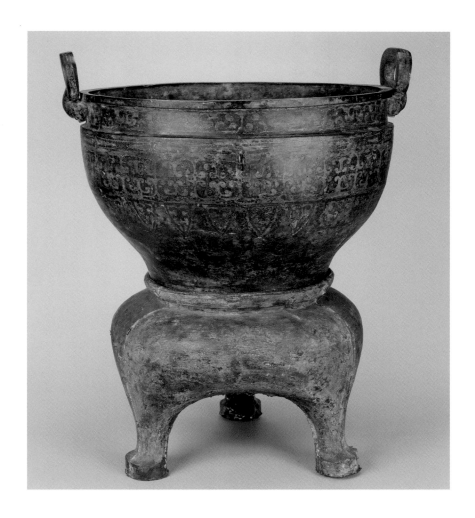

Plate 33

銅甗

FOOD STEAMER FROM SUIXIAN TOMB #1
5th century B.C., Early Warring States period
Bronze, 64.9 x 47.8 cm

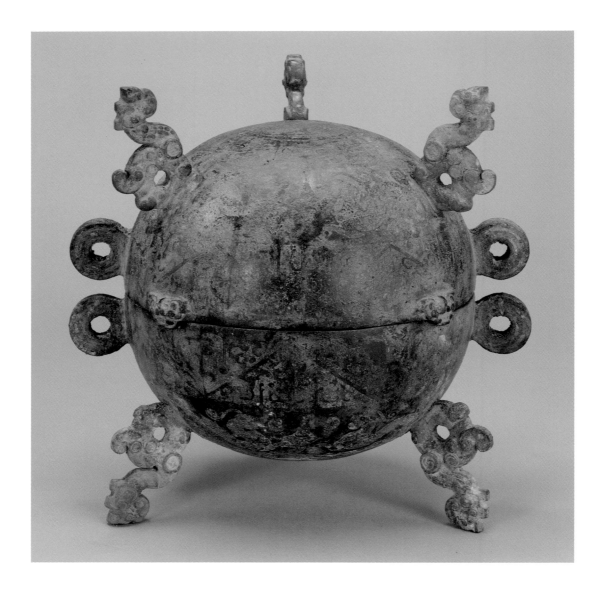

Plate 34

錯紅銅銅敦

FOOD VESSEL FROM XIONGYANG CAIPO TOMB
8th–7th century B.C., Early Spring and Autumn period
Bronze, 27 x 21.5 cm

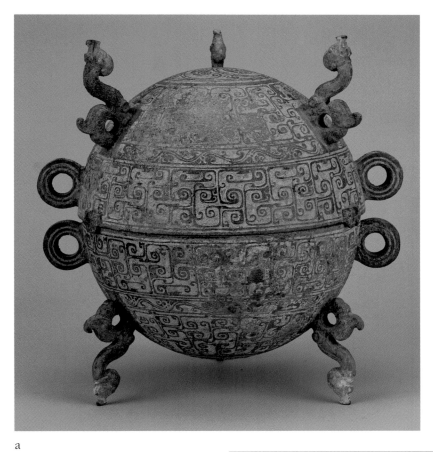

a

Plate 35

嵌地幾何雲紋銅敦

**FOOD VESSEL
FROM ZIGUI TOMB**

8th–7th century B.C.,
Early Spring and Autumn period
Bronze, 22.8 x 17.5 x 9.1 cm

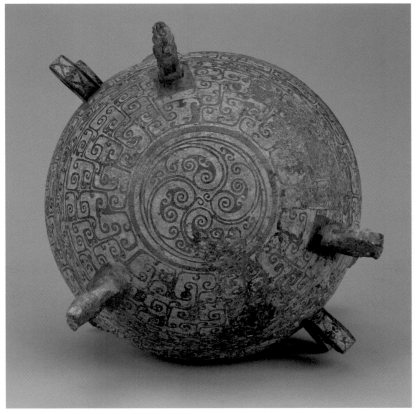

b

a

b

Plate 36

楚屈子赤角銅簠

**FOOD CONTAINER
FROM LIANYUZUI TOMB**
6th–5th century B.C.,
Late Spring and Autumn period
Bronze, 20.3 x 27.7 x 20.9 cm

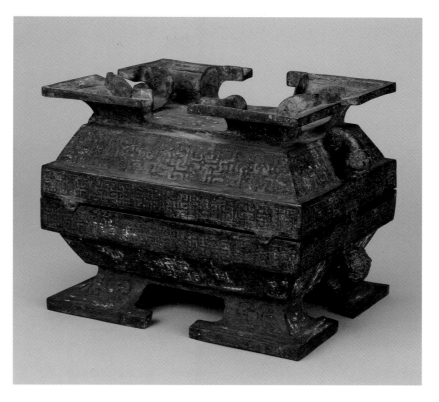

Plate 37

銅簠

**FOOD CONTAINER
WITH LID
FROM SUIXIAN TOMB #1**
5th century B.C.,
Early Warring States period
Bronze, 25.4 cm

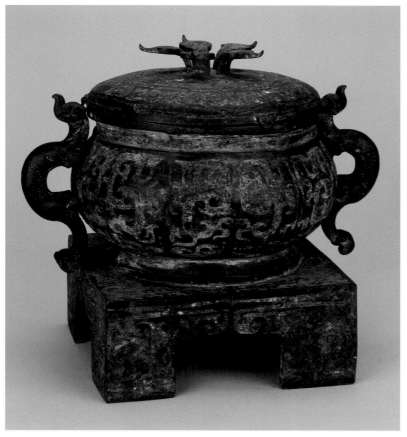

Plate 38

銅簋

**FOOTED FOOD VESSEL
FROM SUIXIAN TOMB #1**
5th century B.C.,
Early Warring States period
Bronze, 31.8 cm

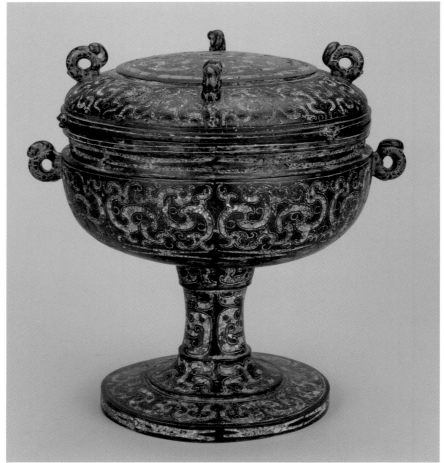

a

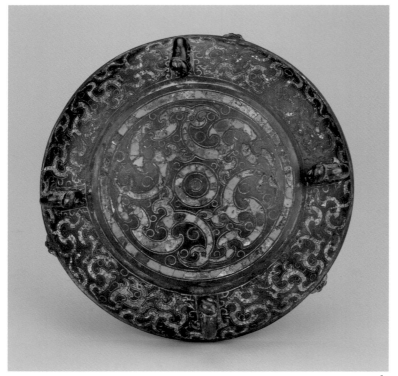

b

Plate 39

銅蓋豆

**LIDDED FOOD VESSEL
FOR CONDIMENTS
FROM SUIXIAN TOMB #1**
5th century B.C.,
Early Warring States period
Bronze inlaid with turquoise,
26.4 x 20.6 cm

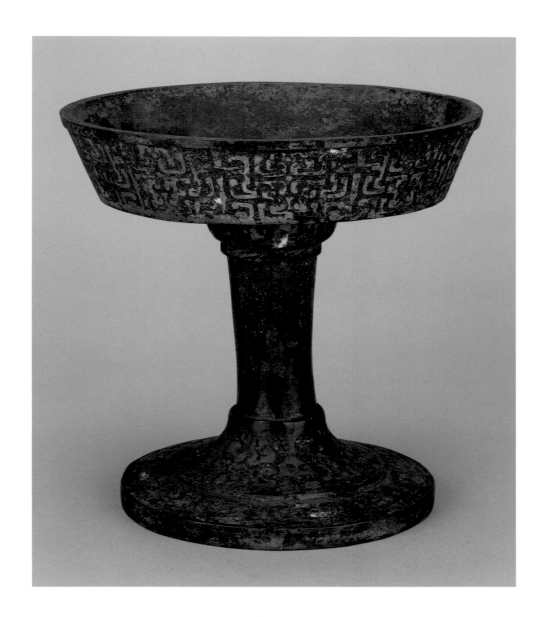

Plate 40

銅淺盤豆
FOOD VESSEL FROM SUIXIAN TOMB #1
5th century B.C., Early Warring States period
Bronze inlaid with turquoise, 21.6 x 21.4 cm

Plate 41

曾中斿父銅方壺

WINE VESSEL
FROM SUJIALONG TOMB
8th–7th century B.C.,
Early Spring and Autumn period
Bronze, 66.7 x 23.1 x 16.3 cm

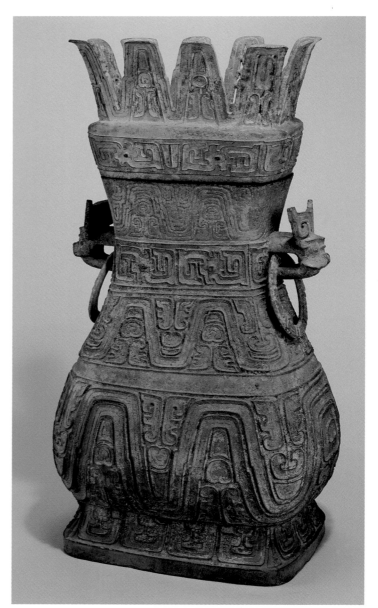

a

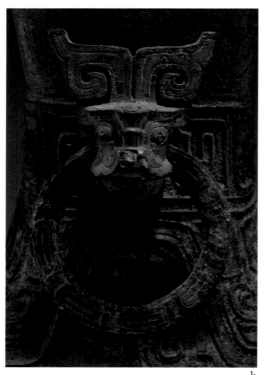

b

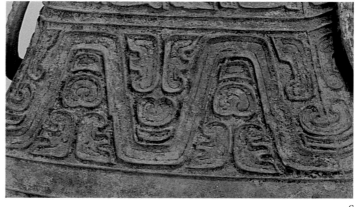

c

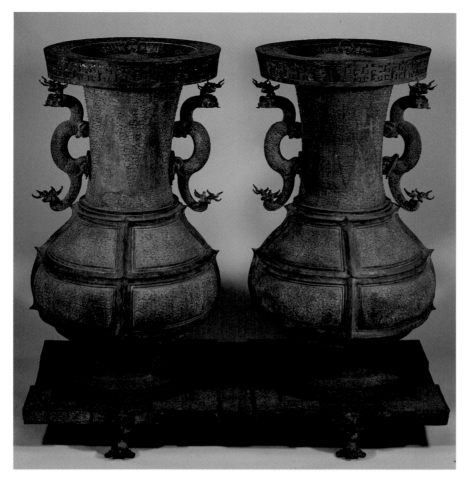

Plate 42

聯禁大壺

**PAIR OF
COVERED WINE
VESSELS ON A
SINGLE STAND FROM
SUIXIAN TOMB #1**
5th century B.C.,
Early Warring States period
Bronze, 99 cm

Plate 43

銅提樑壺

**WINE VESSEL WITH
SWING HANDLE FROM
SUIXIAN TOMB #1**
5th century B.C.,
Early Warring States period
Bronze, 40.5 cm

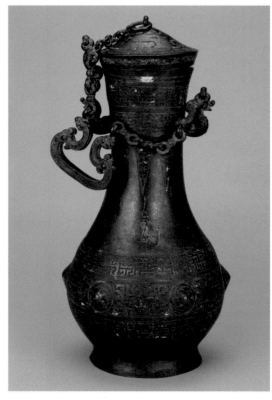

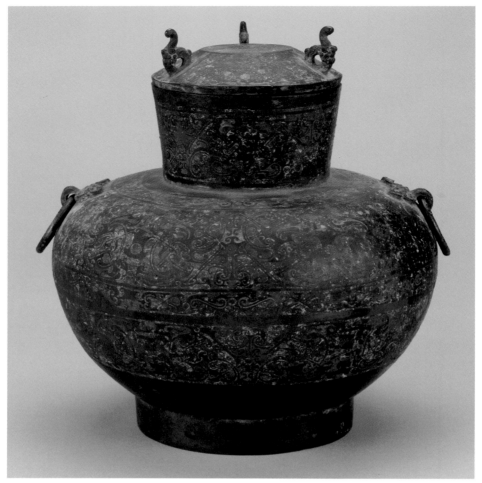

a

b

Plate 44

錯紅銅卷雲紋銅壺

WINE VESSEL FROM BAOSHAN TOMB #2

4th century B.C., Late Warring States period
Bronze inlaid with copper, 22.5 x 9.9 cm

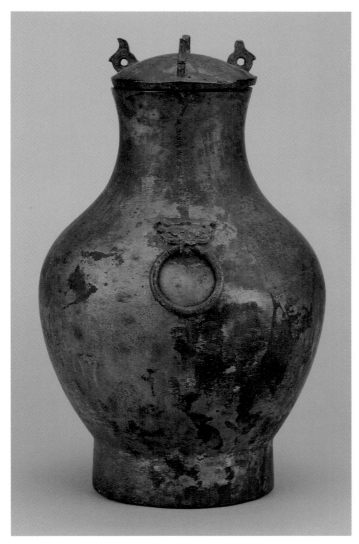

Plate 45

素面銅壺
**WINE CONTAINER FROM
WANGSHAN TOMB #1**
4th century B.C.,
Middle Warring States period
Bronze, 36 x 10.8 cm

Plate 46

竊曲紋銅盤
BASIN FROM ZHIJIANG TOMB
8th–7th century B.C.,
Early Spring and Autumn period
Bronze, 12 x 35.6 cm

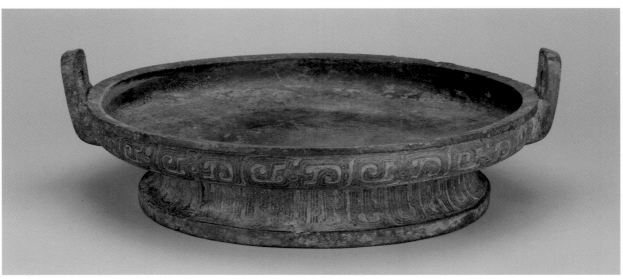

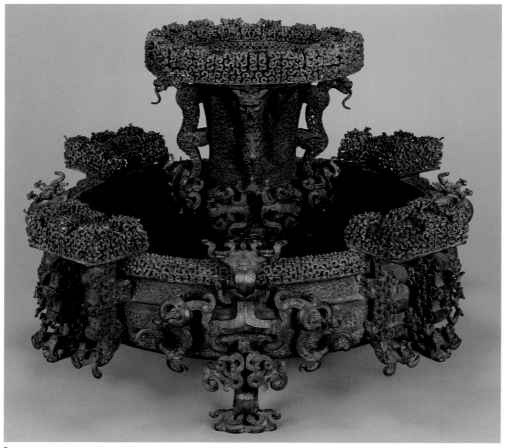

a

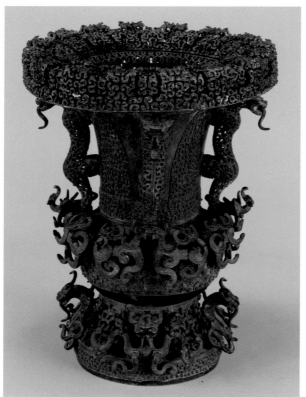

b

Plate 47

尊盤

**WINE VESSEL WITH WATER BASIN
FROM SUIXIAN TOMB #1**
5th century B.C.,
Early Warring States period
Bronze, varied dimensions

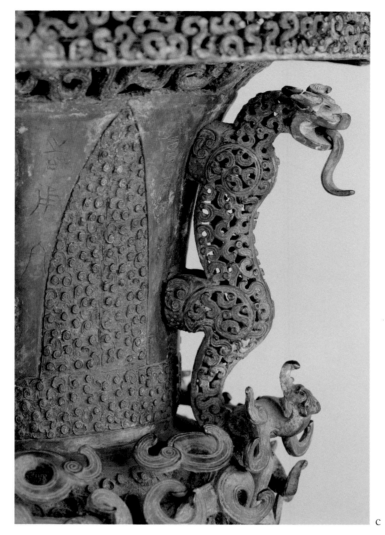

c

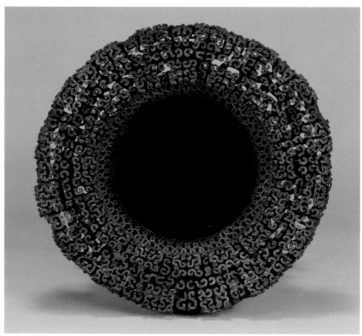

d

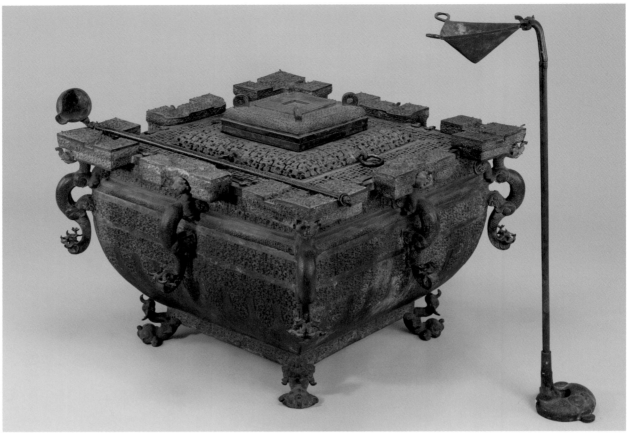

a

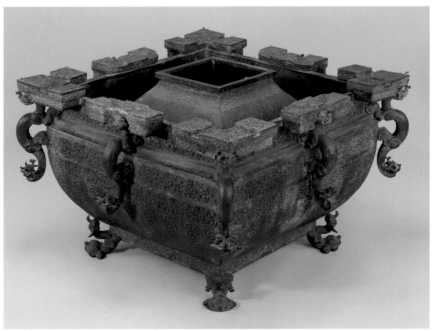

b

Plate 48

鑒缶（附勺、過濾器）
**WINE WARMER OR
COOLER AND FILTER
FROM SUIXIAN TOMB #1**
5th century B.C.,
Early Warring States period
Bronze, varied dimensions

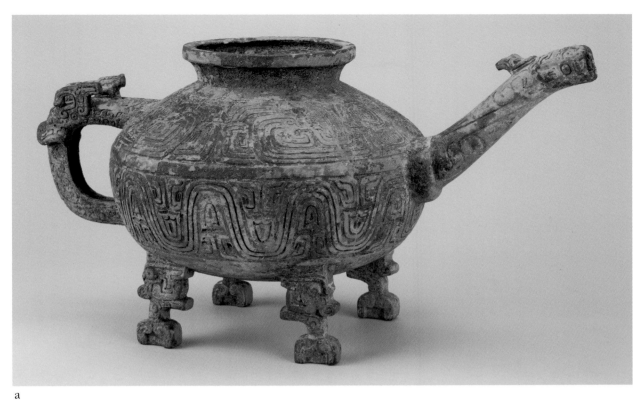

a

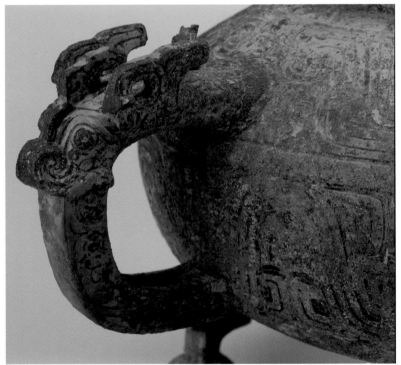

Plate 49

環帶紋盉

**KETTLE FROM
SUJIALONG TOMB**
9th–8th century B.C.,
Late Western Zhou
Bronze, 20.5 cm

b

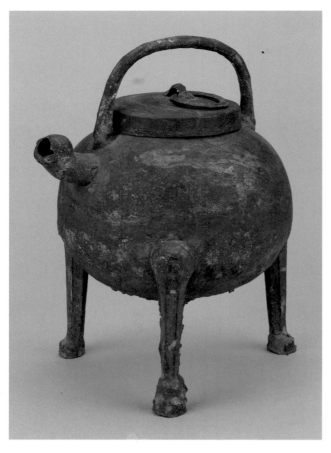

Plate 50

素面銅盉

**SPOUTED WINE AND WATER VESSEL
FROM WANGSHAN TOMB #2**
4th century B.C.,
Middle Warring States period
Bronze, 22.6 x 14.8 x 7.4 cm

Plate 51

塞公孫信父銅匜

**PITCHER
FROM ZHIJIANG TOMB**
8th–7th century B.C.,
Early Spring and Autumn period
Bronze, 20.3 x 14.5 cm

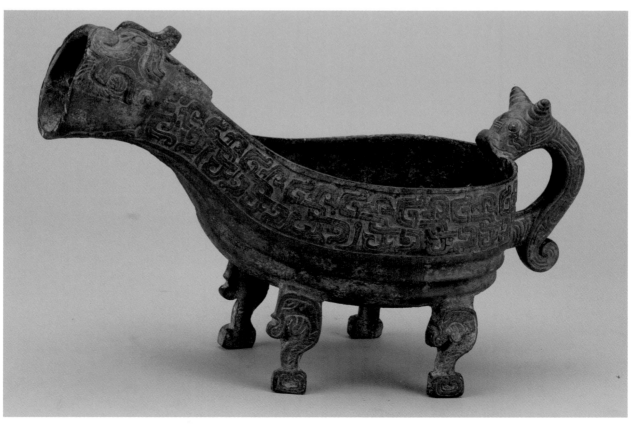

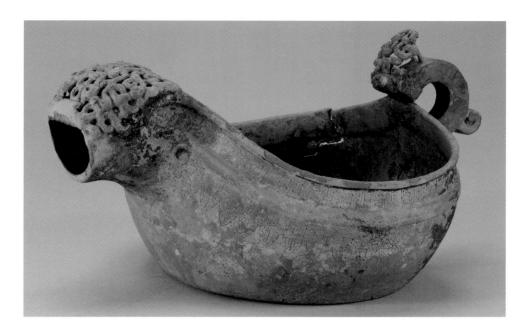

Plate 52

龍柄匜

WATER PITCHER FROM XIANGYANG TOMB
8th–7th century B.C.,
Early Spring and Autumn period
Bronze, 26.5 x 21.5 x 11.5 cm

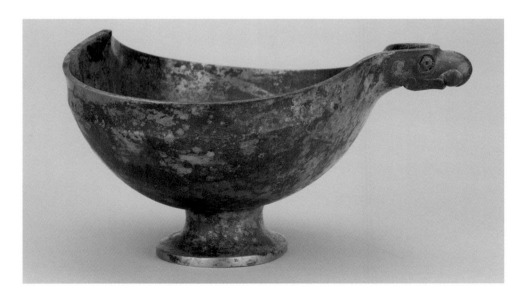

Plate 53

鳥喙形銅杯

SPOUTED CUP FROM BAOSHAN TOMB #2
4th century B.C., Late Warring States period
Bronze, 7.5 x 14.3 cm

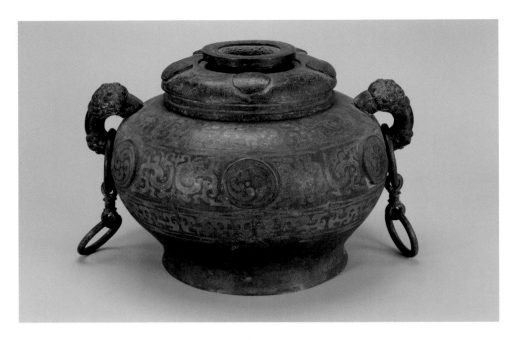

Plate 54

盥缶

WATER JAR FROM SUIXIAN TOMB #1

5th century B.C., Early Warring States period
Bronze inlaid with copper, 36 x 43.8 cm

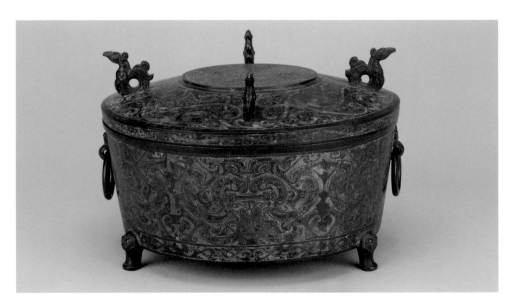

Plate 55

嵌錯龍鳳紋尊

COVERED WINE VESSEL FROM WANGSHAN TOMB #2

4th century B.C., Middle Warring States period
Bronze, 17.1 x 24.7 cm

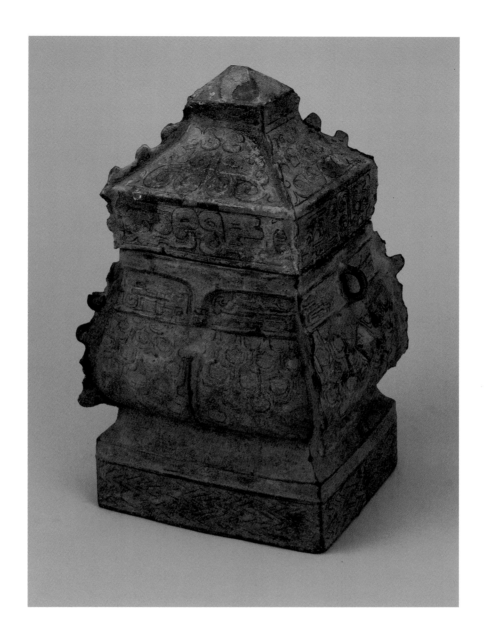

Plate 56

垂鱗紋銅方彝

WINE VESSEL FROM XIONGJIA LAOWAN TOMB
8th–7th century B.C., Early Spring and Autumn period
Bronze, 32 x 12.6 cm

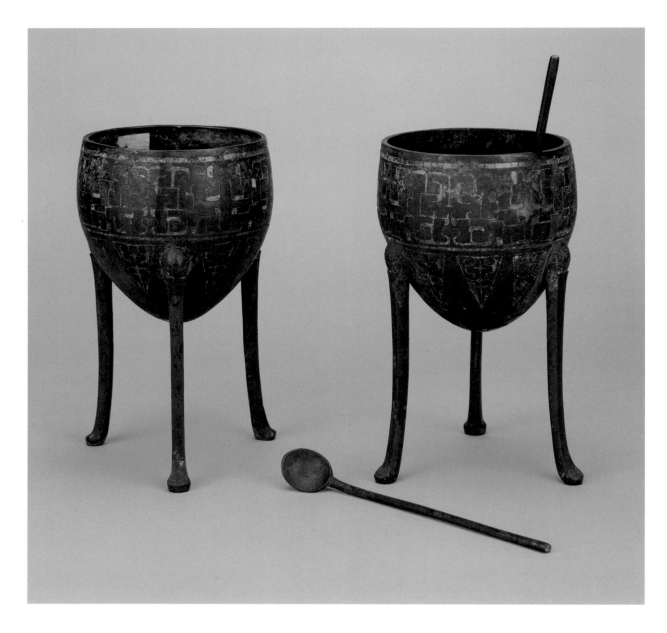

Plate 57

銅鼎形器（附匕 2）

TWO TRIPOD VESSELS AND LADLES FROM SUIXIAN TOMB #1
5th century B.C., Early Warring States period
Bronze, varied dimensions

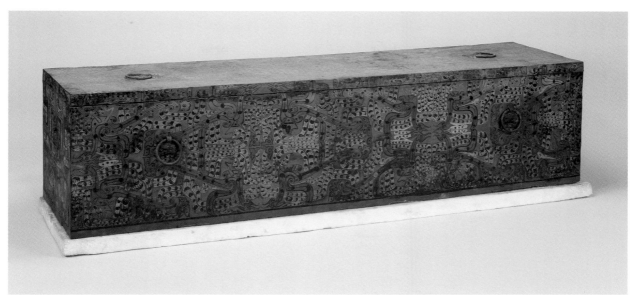

a

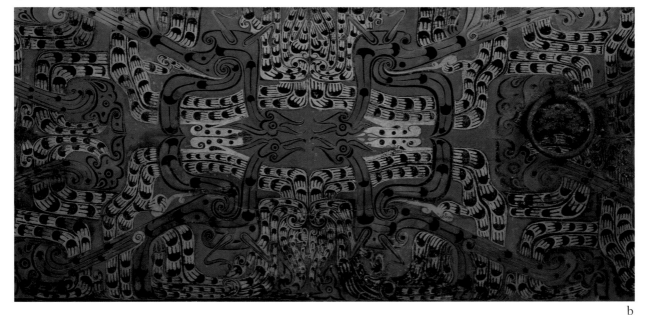

b

Plate 58

漆內棺
INNER COFFIN FROM BAOSHAN TOMB #2
4th century B.C., Late Warring States period
Polychrome lacquer over wood, 46 x 184 x 46 cm

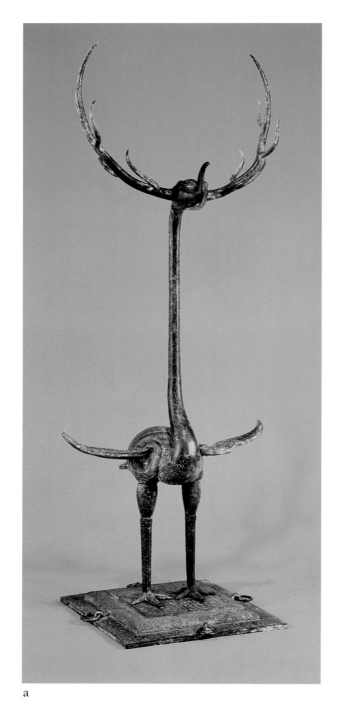

a

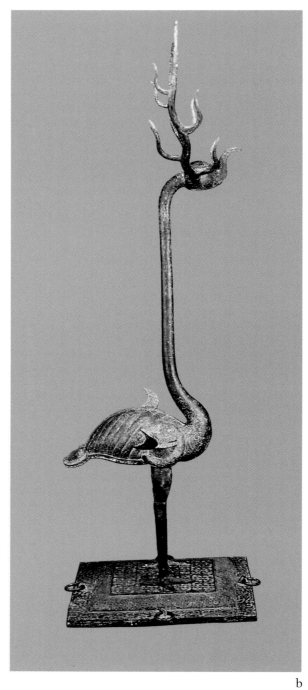

b

Plate 59

鹿角立鶴

ANTLERED CRANE FROM SUIXIAN TOMB #1
5th century B.C., Early Warring States period
Bronze, 143.5 x 38.4 cm

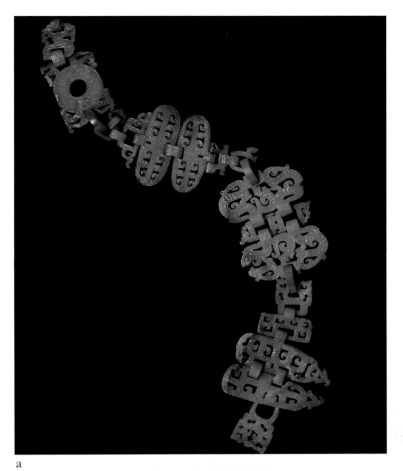

a

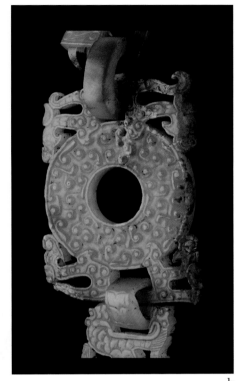

b

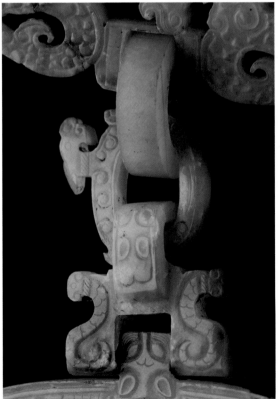

c

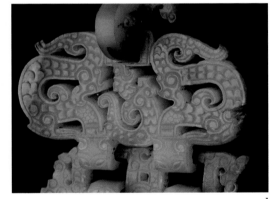

d

Plate 60

十六節龍鳳玉佩

**ORNAMENT FROM
SUIXIAN TOMB #1**
5th century B.C.,
Early Warring States period
Jade, 48 cm

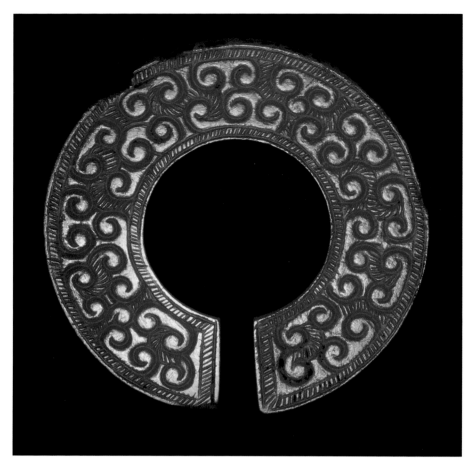

Plate 61

雲紋玉玦
**ORNAMENT FROM
SUIXIAN TOMB #1**
5th century B.C.,
Early Warring States period
Jade, 5 cm

Plate 62

玉握一對
**TWO FUNERARY
ACCESSORIES FROM
SUIXIAN TOMB #1**
5th century B.C.,
Early Warring States period
Jade, 4.8 x 1.8 x 2.1 cm

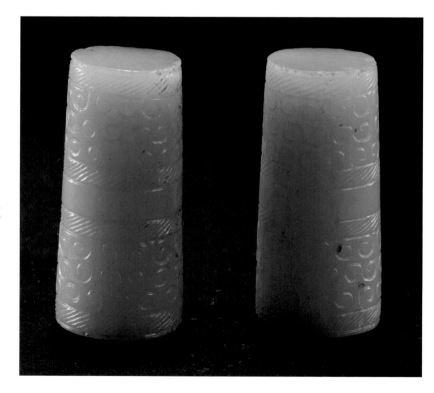

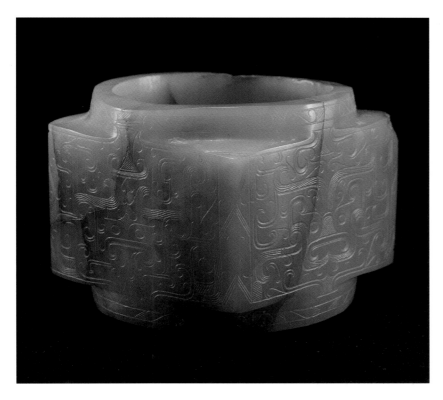

Plate 63

獸面紋玉琮

**RITUAL OBJECT FROM
SUIXIAN TOMB #1**
5th century B.C.,
Early Warring States period
Jade, 5.4 x 6.6 cm

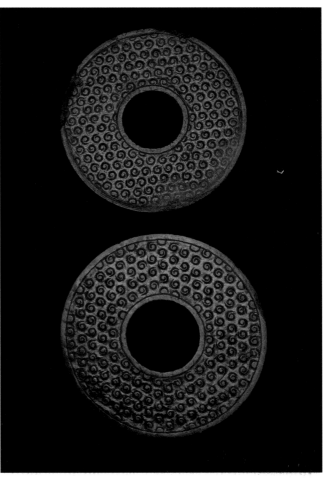

Plate 64

玉（望山）

**TWO DISCS FROM
WANGHSAN TOMB #1**
4th century B.C.,
Middle Warring States period
Jade, varied dimensions

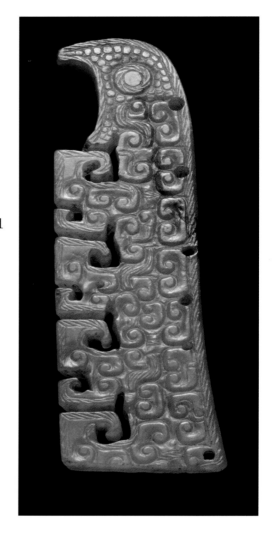

Plate 65

鳥首形玉佩

**ORNAMENT
FROM SUIXIAN TOMB #1**
5th century B.C.,
Early Warring States period
Jade, 9.3 x 2.9 cm

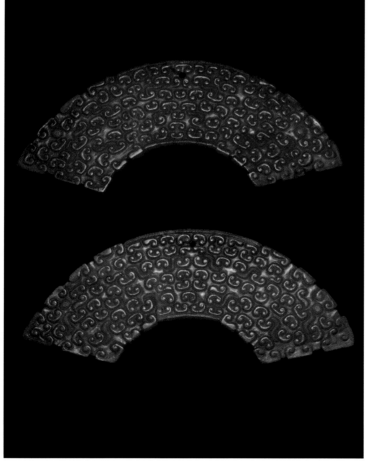

Plate 66

雲紋玉璜一對

**TWO PENDANTS
FROM SUIXIAN TOMB #1**
5th century B.C.,
Early Warring States period
Jade, 11.1 x 2.1 cm

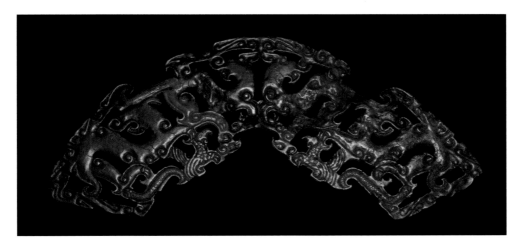

Plate 67

透雕玉璜

PENDANT FROM SUIXIAN TOMB #1
5th century B.C., Early Warring States period
Jade, 16 x 4.7 cm

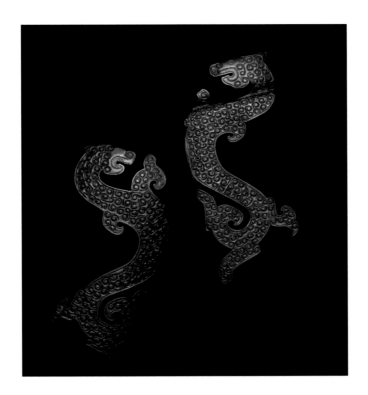

Plate 68

龍形玉佩（望山）

PAIR OF PENDANTS FROM WANGSHAN TOMB #3
4th century B.C., Middle Warring States period
Jade, 13.2 x .6 cm

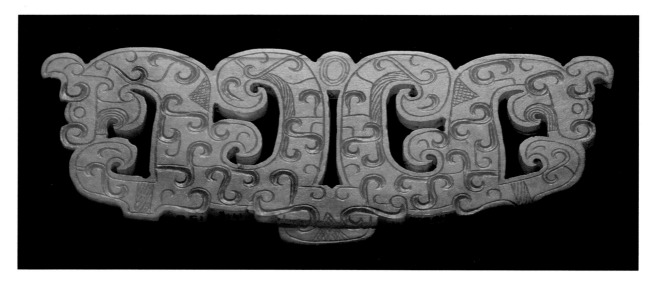

Plate 69

雙龍玉佩

PENDANT FROM SUIXIAN TOMB #1
5th century B.C., Early Warring States period
Jade, 11.3 x 7.7 cm

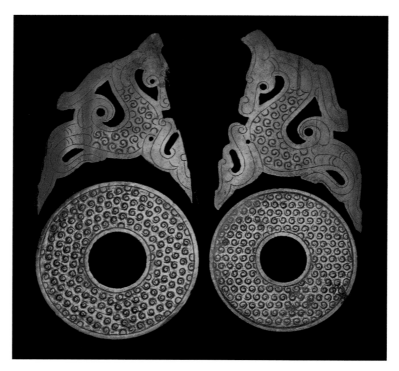

Plate 70

玉佩（望山）

PAIR OF PENDANTS FROM WANGSHAN TOMB #2
(shown with discs from Pl. 64)
4th century B.C., Middle Warring States period
Jade, varied dimensions

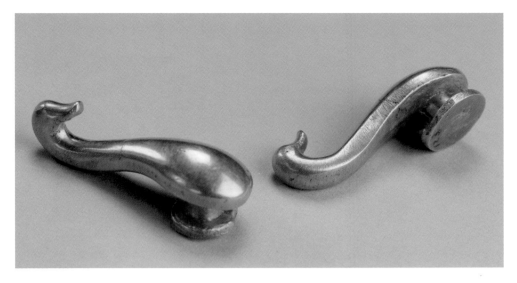

Plate 71

金帶鉤一對

TWO BELT HOOKS FROM SUIXIAN TOMB #1
5th century B.C., Early Warring States period
Gold, 4.4 cm

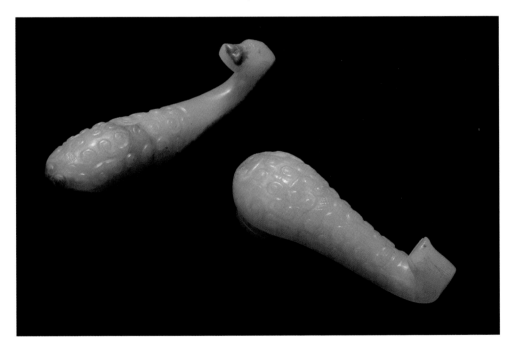

Plate 72

雲紋玉帶鉤一對

TWO BELT HOOKS FROM SUIXIAN TOMB #1
5th century B.C., Early Warring States period
Jade, 5.2 x 1.9 cm

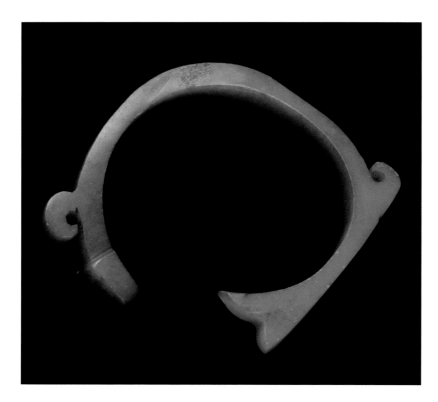

Plate 73

圓雕玉龍佩

**PENDANT FROM
SUIXIAN TOMB #1**
5th century B.C.,
Early Warring States period
Jade, 7.6 x 1.6 cm

Plate 74

瑪瑙杯（望山）

**TWO BRACELETS FROM
WANGSHAN TOMB #1**
4th century B.C.,
Middle Warring States period
Agate, varied dimensions

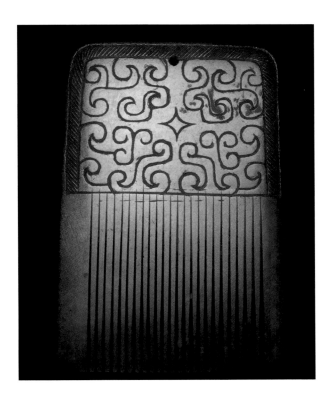

Plate 75

玉梳

COMB FROM
SUIXIAN TOMB #1
5th century B.C.,
Early Warring States period
Jade, 9.6 x 6.5 cm

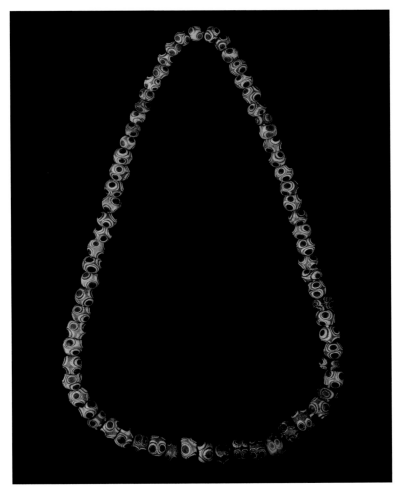

Plate 76

料珠

NECKLACE
FROM SUIXIAN
TOMB #1
5th century B.C.,
Early Warring States period
Glass, varied dimensions

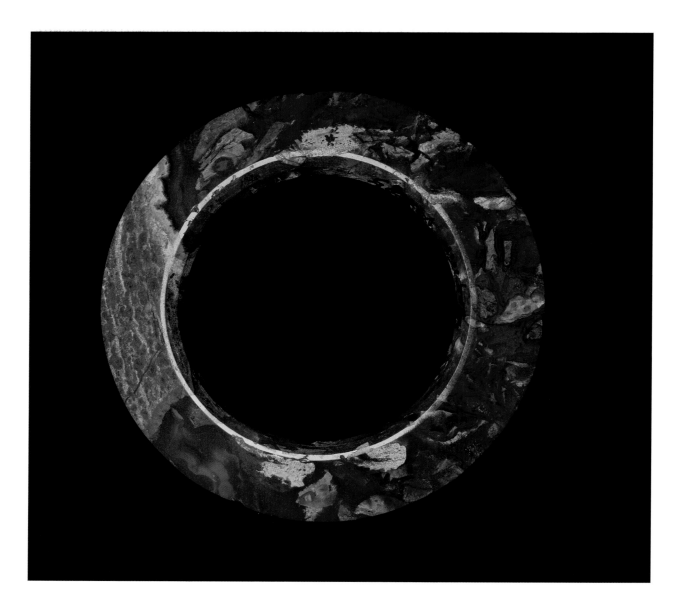

Plate 77

玉(望山)

BRACELET FROM WANGSHAN TOMB #1
4th century B.C., Middle Warring States period
Jade, 6.4 cm

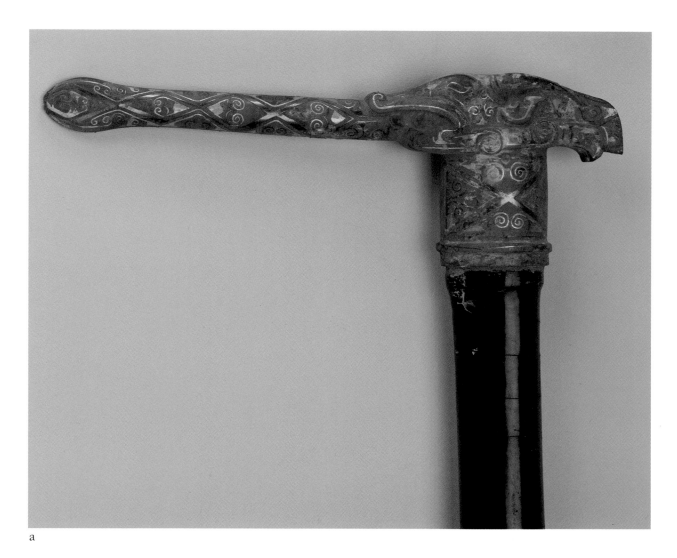

a

Plate 78

錯金龍首杖

STAFF FROM BAOSHAN TOMB #2
4th century B.C., Late Warring States period
Metal inlaid with gold, lacquered wood support, 155.2 cm

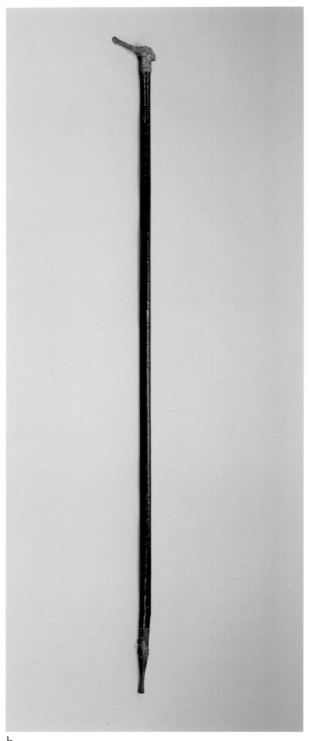

b

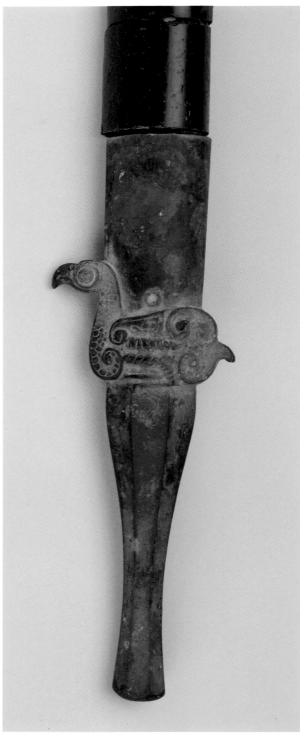

c

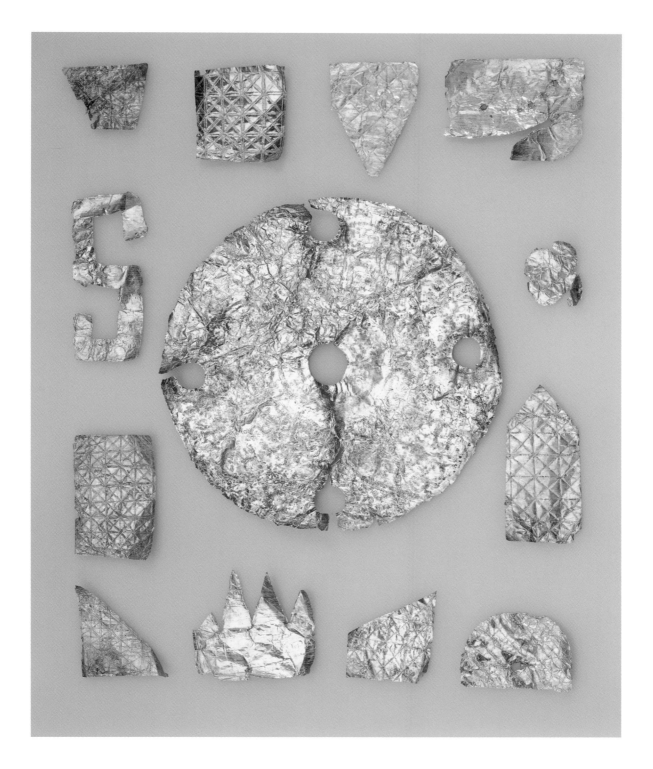

Plate 79

金箔（13 件）

THIRTEEN ORNAMENTAL FITTINGS FROM SUIXIAN TOMB #1
5th century B.C., Early Warring States period
Gold leaf, varied dimensions

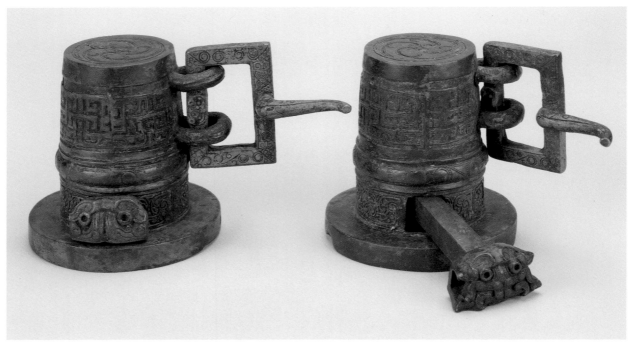

a

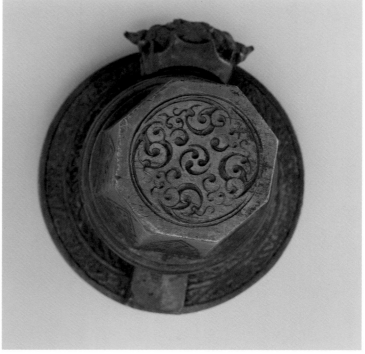

b

Plate 80

車軎

FIVE PAIRS OF WHEEL AXLE CAPS FROM SUIXIAN TOMB #1
5th century B.C., Early Warring States period
Bronze, varied dimensions

108

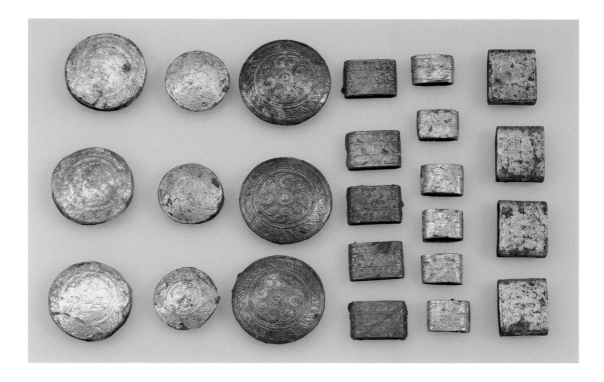

Plate 81

貼金箔馬飾

TWENTY-FOUR HORSE STRAP FITTINGS FROM SUIXIAN TOMB #1
5th century B.C., Early Warring States period
Metal with applied gold leaf, varied dimensions

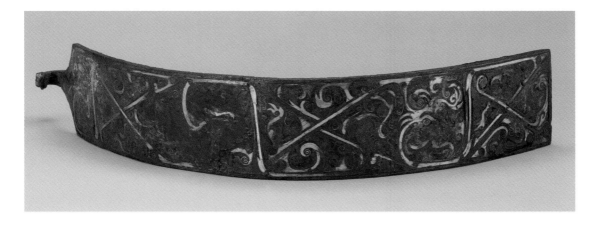

Plate 82

錯金銀龍鳳紋鐵帶鉤

DRAGONHEAD BELT HOOK FROM WANGSHAN TOMB #1
4th century B.C., Middle Warring States period
Iron inlaid with gold and silver, 46.2 x 6.5 x .5 cm

LUXURY

ARISTOCRATIC LIFE

The most evocative picture we have of aristocratic life in Warring States China in the southern regions comes from the poetry of Chu. A poem attributed to Qu Yuan called *Zhaohun* (Summoning the Soul) describes the practice of hiring shamans to call to a soul believed to have departed the body and left its owner in danger. The shaman offered two good reasons to return-elsewhere is horrifying and home is pleasing in every way. The soul-summoner's description of delights of the aristocratic life on earth allows us to place the vessels, ornaments, and other objects found in these tombs within the context of the living.

> *Hear while I describe for you your quiet and*
> > *reposeful home.*
> *High halls and deep chambers, with railings*
> > *and tiered balconies;*
> *Stepped terraces, storied pavilions, whose tops look*
> > *on the high mountains;*
> *Lattice doors with scarlet interstices, and carving*
> > *on the square lintels;*
> *Draftless rooms for winter; galleries cool in summer;*
> *Streams and gullies wind in and out, purling prettily;*
> *A warm breeze bends the melilotus and sets the tall*
> > *orchids swaying.*
> > <p style="text-align:center">✳</p>
> *Beyond the hall, in the apartments, the ceilings*
> > *and floors are vermilion,*
> *The chambers of polished stone, with kingfisher*
> > *curtains hanging from jasper hooks;*
> *Bedspreads of kingfisher seeded with pearls,*
> > *dazzling in brightness;*
> *Arras of fine silk covers the walls; damask canopies*
> > *stretch overhead . . .*
> *Bright candles of orchid-perfumed fat light up*
> > *flower-like faces that await you;*

The poem goes on to mention delicacies and entertainment one is likely to find upon returning home:

> *Stewed turtle and roast kid . . . braised chicken, seethed*
> *terrapin, high-seasoned but not to spoil the taste . . .*
> *Jadelike wine, honey-flavored fills the winged cups; ice-*
> *cooled liquor strained of impurities, clear wine, cool and*
> *refreshing. Here are laid out patterned ladles, and here is*
> *sparkling wine . . . The lovely girls are drunk with wine,*
> *their faces are flushed . . . Bells clash in their swaying*

> *frames, the catalpa zither's strings are swept . . . Their*
> *sleeves rise like crossed bamboo stems, then slowly shim-*
> *mer downward. Pipes and zithers rise in wild harmonies,*
> *the sounding drums thunderously roll, and the courts of*
> *the palace quake and tremble as they throw themselves*
> *into the whirling Chu.*

When it became clear that the soul would not return to the body, the tomb was prepared. Family members then provided all this *luxe et volupté* for the hereafter.

AUSPICIOUS OBJECTS

The function of some objects that accompanied the deceased in the afterworld is thought to have been talismanic. The most notable example of this in the exhibition is the large, long-necked bronze bird. The Pl. 59 fantastic creature resembles a crane, but bears a pair of four-pronged antlers that arc in a circular form above its head. It stands straight legged, with wings spread as if to fly. The antlers, body, legs, and wings were cast separately and later assembled using bronze mortise and tenon construction. This clear adaptation of the wood joinery from the many wooden examples of long-necked birds in Chu tombs suggest that the Marquis Yi's antlered crane is an expression, in a more precious medium, of models developed in wood.

The bird was placed next to the coffin of the Marquis Yi, and an inscription on the right side of the beak identifies it as "made for the eternal use of the Marquis Yi of Zeng." The object was certainly intended to function in the afterlife; whether it was made solely for burial purposes or if it might have held a drum is not clear. The bird stands on a flat square base-cast with patterns of clouds, serpents and birds-with four rings, which suggests that the figure may have been attached to something or carried by these means.

A clear example of the seven-character inscription-made for the eternal use of the Marquis Yi of Zeng-is found on this ladle

Birds resembling the crane of the Marquis Yi-long-necked, straight-legged, and wings outstretched-have been found in 4th- and 3rd-century-B.C. Chu tombs. None, however, combines all the features of the Suixian example-made in valuable metal, placed near the coffin, and bearing antlers on the head.

In the 4th-century-B.C. Tomb M1 at Tianxingguan, Jiangling, Hubei Province, a similar but smaller bird was found, not in the coffin chamber but in an adjacent chamber. It has antlers as a tail, rather than on the head. The Tianxingguan bird, similar to most found in Chu tombs, was carved from wood and painted in lacquer. Tomb #166 at Yutaishan, Jiangling, Hubei Province, also yielded a carved wood bird with antlers reaching out from the body rather than the head. This bird stands atop a tiger.

Pairs of similar wooden birds (without the mysterious antlers) positioned tail to tail, facing away from one another, and standing on tigers, have been found in several Chu tombs. One such pair from Wangshan Pl. 22 Tomb #1 is shown in this exhibition. Here, birds form the frame of a drumstand. The metal drum plate was suspended between the birds from their crests. A very similar drumstand, with its painting in a better state of preservation, was found in the Tianxingguan tomb.

If we look for examples of antlered beasts other than birds, we find many examples of so-called *zhenmushou* (tomb protecting animals) from Chu tombs. Over 150 of these creatures have been found in the Jiangling area within tombs associated with people of high rank.[1] An early example is found in Tomb #4, a late Spring and Autumn period tomb (6th century B.C.) at Dangyang, Hubei Province. The Tianxingguan tomb also housed a pair of back-to-back monsters with magnificent double antlers and protruding tongues. Antlers seem to have had some cultic function, and they appear with greater frequency in southern tombs than in northern ones.

The magical function of antlered monsters is suggested by a find in the Chu Tomb #1 near Xinyang, Changtaiguan. In this tomb, a chamber directly behind the coffin chamber held only five objects. A carved and painted wooden, antlered, long-tongued *zhenmushou* stood in the center. Four crudely carved figures of humans, were placed in the four corners of the room.

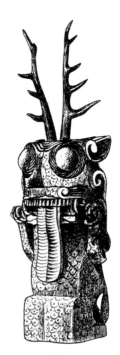

Tomb guardian figure (adapted from Loewe and Shaughnessy, The Cambridge History of Ancient China)

The figures were naked, and one had a needle piercing its chest. Their relationship to the antlered monster indeed provokes speculation.

NATURALISM

Deer antlers seem to have been appropriated for magical creatures, and the meaning of this arrangement remains illusive. A carved, seated deer with a magnificent pair of real antlers taken from a sika deer (a small, reddish deer indigenous to eastern Asia), was found in the ceremonial hall of the tomb of the Marquis Yi. The antlers were painted with patterns similar to those on the horns of the back-to-back, antlered monsters from Tianxingguan. This composed and relaxed animal, however, shows no fearsome traits. Its head rotates at the neck, and it can assume a range of naturalistic poses. This movement imparts an added dimension of lifelikeness to the creature. It could view and be viewed from different directions. Was it a sculpture to be appreciated as an object of serenity? A "spirit article," a representation made specifically as a companion in the grave for the Marquis Yi?[2] Whatever its Pl. 83

1 Wu Hung, "Art and Architecture of the Warring States Period," 740.

2 From the tomb of the king of Zhongshan, Pingshan County, Hebei Province, was excavated in 1977 an elaborate bronze table base, with four deer around the bottom crouched in a position similar to Yi's deer. Above these placid creatures are straining dragons interlaced with powerful birds. The antlers of the two male deer are modest and without branches. See *Treasures: 300 Best Excavated Pieces from China* (Beijing: New World Press, 1992), 181-82.

function, the deer represents a distinctive artistic accomplishment. It was clearly made from observation of nature, and this quality was preserved in the artistic representation, with the scale of the antlers exaggerated.[3]

Pl. 97

The introduction of a naturalistic style in the creation of objects-including an increasing presence of the human figure during the Warring States period-is a dramatic shift in the history of Chinese art. Although zoomorphic and geometric design remained staples of the decorative vocabulary, and fantastical animals and humans abounded, there was also the appearance of a distinct, naturalistic style rooted in observation of and interest in this world.

Pl. 18

Two scenes on the sides of the duck-shaped, lacquered box are examples of pictorial space, appearing as if a stage set against a backdrop of patterns that is suggestive of the markings on a duck. At least three kinds of image production are at play. Within the frame of the stage, entertainments are portrayed. On one side a birdlike figure plays a shafted drum, while a sword-toting dancer flings a long sleeve and twists to the rhythms. On the other side, a bird figure, perched on the haunches of an animal that forms one side of a bell-frame, plays a bell by hitting it on the side with a long pole. This use of imaginary creatures in "real" space is one set of conventions for image-making, or perhaps two; both real and imaginary creatures can occupy "real" space. Beyond the borders of the stage are geometric patterns, suggestive of the diverse patterning of feathers on a duck, but not imitative of them. Here patterning is used in a decorative way. The third level of image-making is the sculptural rendering of the duck itself, which is divided into container and lid and serves as a box. This free combination of kinds of imagery and imagination is characteristic of 5th-century-B.C. Chu style. Irresolution into any consistent system gives this art a playful air. It was a time of undeniable creativity.

A hint of what may have been a more elaborately developed narrative tradition in painting a century later is provided by a painted lacquer box from Baoshan Tomb #2. The sides of the box relate, on a small and intimate scale, a human story in sequential episodes. The episodes are separated by gracefully rendered trees. Reading from right to left, a gentleman is driven in a chariot; attendants run ahead, the chariot slows before a kneeling figure. The traveler disappears from the narrative for one episode, in which two gentlemen walk in the direction of the approaching chariot. After another tree marker, the chariot is turned around and waiting, and the traveler faces the approaching gentleman. Two attendants stand with their backs to the picture plane and appear lower in the composition, thus indicating their relative proximity to the viewer. The event shown is a meeting of some significance. The directional movements of the key figures are reinforced by birds flying above them. The birds meet at the empty carriage, reversed for its return.[4]

This pictorial narrative is fully conceived in space and time, using several conventions that would continue to be employed by Chinese artists for over a thousand years. The appearance of so advanced a picture on an object of apparently personal, rather than ritual, significance is again an indication of a shift of artistic attention to items of secular luxury and of major advances in available modes of pictorial representation.

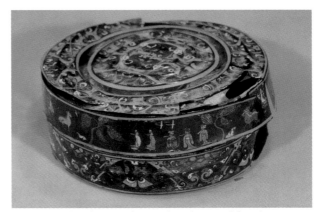

Painted toilet box from Baoshan Tomb #2 (not in exhibtion)

Pictorial ambition reached portraiture during the Warring States period. Two paintings on silk from Warring States period Chu tombs have been interpreted as actual portraits of the deceased, one a man (from Zidanku, Changsha, Hunan Province) and one a woman (from Chenjiadashan, Changsha, Hunan

3 A notable feature of the recumbent deer is the fold of the legs. The rear legs overlap a front leg, hoof upturned. This is a characteristic pose for representing stags developed throughout the Eurasian steppes by the early 1st millennium B.C., which by the 5th century B.C. seems fully integrated into southern Chinese pictorial conventions. Elaborate antlers and the head regardant are also often found on stags from the tribes who frequented China's northwest borders. See Jenny So and Emma Bunker, *Traders and Raiders on China's Northern Frontier* (Washington, D.C.: Smithsonian Institution Press, 1995), 110-11.

4 This imagery is fully discussed in Wu Hung, "Art and Architecture of the Warring States Period."

Province).[5] It might be noted that a crane, with open wings and stretched neck (the position of the antlered bird in Marquis Yi's coffin chamber), accompanies the male figure on his journey in a dragon-drawn chariot.

EXTRAVAGANCE

Several objects in this exhibition celebrate a characteristically southern Chinese taste during the Warring States period for a dense profusion of elements, juxtapositions of contrasting patterns, and extrusions projecting dynamically from the surface of objects. This feature, in bronze, is seen vividly in the stand for the shafted drum and the bases beneath the figures supporting the bell stand from the tomb of Marquis Yi.

Pls. 23 17, 47

The *pan-zun* from this tomb is perhaps the most ornate ritual object in early Chinese art history-its billowing openwork forms defying traditional forms made possible by the technique of lost wax casting. Its ornateness is challenged only by objects such as a large rectangular stand for wine (*jin*) covered with a multi-layered perforated cloud design, and held up by ten walking tigers from Tomb #2 at Xiaxi, Xichuan, Henan Province, dated to the middle of the 6th century B.C., the earliest recorded appearance of the use of the lost wax method.

Pl. 87

In lacquer, the pride of place for extravagant design and construction is held by the covered *dou* (food vessel) from the tomb of Marquis Yi. The *dou* was carved in wood and then painted. Elaborate handles built out from the lid and body meet to form looped dragons. The degree of extravagance can be measured by comparing the silhouette of this object to the more typical form of an inlaid *dou*. Parts of the vessel have been carved separately and then joined together. The relative restraint of several different geometric designs confined to registers on the surface of the body of the *dou* breaks loose in the handles and within a circle on the lid, in which three writhing dragons intertwine in an unfathomable pattern. There are traces of gold on the dragon scales. This is art that engages the beholder on a visceral rather than a rational level.

Pl. 39

One of the most ingeniously conceived and artfully executed objects found in a Warring States burial is the small desk screen from Tomb #1 at Wangshan. The piece functions as both a silhouette and in three dimensions, as both pattern and individually conceived forms. If divided in the middle, it is seen as a single pattern doubled. But it is the syncopation of rhythm that occurs when two repeats are abutted that activates the design. The center of the repeat is a bird plunging downward with a circle of intertwined snakes in its beak. The bird is flanked by two deer in a flying gallop. Between the hind legs of the deer rise the necks of the phoenixes, which face away from the center. Even the bottom of the screen is elaborately carved with writhing snakes and frogs. The conservation of this piece was a four-year-long process.

Pl. 85

Working with lacquer is a labor-intensive process, requiring the application in repeated thin layers of boiled and filtered sap from the lac tree, *Rhus vernicflua*. The lacquer must be dried in humid conditions between each application. It must also be maintained in humid conditions. (Ironically, it was the water-logged circumstances of the Suixian find that preserved the lacquer so well, as the pressure of the water inside of the tomb prevented the collapse of the tomb from the pressure of the surrounding earth.[6]) The resulting fine seal and smooth surface made lacquered objects highly desirable for food and storage vessels, as well as receptive to surface design. Lacquer is not as inherently valuable a material as bronze, but high-quality lacquerware was available only to the most wealthy. The quality of lacquer in these burials is consistent with other evidence of the status of the deceased. Lacquer is found in both northern and southern burials, but more commonly in the south.

UTILITARIAN WARE

Lacquer and wood were used in various parts of the decorative environment in south China. Walls were painted with pigmented lacquers, as was furniture. Lacquer does not hold all colors easily, and takes vermilion most firmly. Red and black (or brown-black) dominate the palette of lacquer decoration, although other colors, including white, silver, yellow, and brown appear. Yellow tends to disappear in lacquer, and in several cases, traces of bright yellow powder can be discerned in areas that now appear to be

5 The ritual use of these paintings as name banners to represent the deceased while mourners visited the coffin is discussed in Wu Hung, "Art in its Ritual Context: Rethinking Mawangdui," *Early China* 17 (1992): 111-45.

6 Colin Mackenzie, "Chu Bronze Work," 107ff.

THE PRESERVATION OF UNEARTHED LACQUERWARE

CHEN ZHONGXING

Adapted from "Glyoxal Method for Dehydration, Reinforcement, and Shape-Fixing of Painted Coffins Unearthed from the Tomb of Zhenghou Yi and the Tomb at Baoshan."

The Preservation of Unearthed Lacquerware and Woodenware

Since the 1960s, over 6,000 lacquer and wooden artifacts have been unearthed in the region of Jinzhou, the city of Suizhou, the county of Yunmeng, and the region of Yichang. These artifacts belong, respectively, to the Spring and Autumn period, the Warring States period, the Qin dynasty, and the Han dynasty.

These precious relics, which were saturated with water when they were discovered, had to be preserved by immersion in water so as to avoid the shrinking, cracking, and warping that would be caused by natural drying. Although this immersion preserved the shape of the relics, the specimens continued to corrode and deteriorate-the wooden cores were rotting, the coating continued to come off, and the color was gradually fading. It was therefore absolutely necessary to determine by which scientific methods of preservation these cultural relics could be dehydrated, reinforced, and fixed in shape.

Conservation Techniques of Lacquerware and Woodenware in China and Abroad

In China, not only have many wooden artifacts been unearthed, but also a large number of elegant and beautiful lacquer works have been discovered in archaeological excavations. As only wooden artifacts have been found in other places in the world, the lacquerware are treasures unique to China.

According to the published literature, research outside of China into the preservation of woodenware has concentrated on the use of polyethylene glycol (PEG) to dehydrate, reinforce, and fix in shape wooden artifacts. This method has also been studied in China, but was found to cause considerable shrinkage, produce cracks, result in dark and waxy appearances, and leave objects susceptible to damp.

Since the 1970s, wide-ranging research has been conducted in China as to better methods for the preservation of ancient lacquer and wooden artifacts, and some advances have been made. However the methods commonly used at present-including natural drying; impregnation with alcohol ether; impregnation with alcohol ether and resin; freeze-sublimation drying; vacuum drying; impregnation with PEG; impregnation with glycerin; and impregnation with silica gel-have proved to have their limitations, and have shown the need for still further research.

The Conservation Technology Division of the Hubei Provincial Museum has succeeded in its efforts, which began in 1973, to develop a method for dehydration and shape-fixing using glyoxal. The procedures developed have been shown to be of use with both lacquerware and woodenware.

The Glyoxal Treatment for Dehydration, Reinforcement, and Shape-Fixing

The treatment proceeds as follows. The artifact is immersed in the glyoxal liquid mixture (glyoxal, catalyst, addictive, and penetrant). Under certain conditions of temperature and pressure, the water in the artifact is replaced by the liquid mixture. When the unit weight of the liquid is constant, the specimen is removed from the liquid. A polyreaction takes place in the glyoxal liquid mixture that has penetrated the specimen. After this reaction, the specimen is subjected to a drying treatment under specified temperatures.

Tests following treatment show the success of this treatment. The tensile strength of the wooden planks is increased (showing that the glyoxal polymer acts as a reinforcement agent of the wood fibers; the defects in the wooden material that have appeared in the 2,400 years of submersion are filled by the glyoxal polymer; and infrared spectrum analysis shows that the strength of the wooden fibers is increased.

The Treatment of Lacquer Coffins

The painted inner and outer coffins from the tomb of the Marquis Yi were unearthed in 1978. The painted inner coffin of the tomb at Baoshan (which is included in this exhibition) was unearthed in 1986. Before being dehydrated, these coffins were wrapped with plastic film and continuously sprayed with water for the purpose of conservation. Examinations revealed these coffins to be made of catalpa wood.

Pl. 58

continued

LUXURY

The Preservation State of the Inner Coffin from the Tomb of the Marquis Yi

The inner coffin from the tomb of the Marquis Yi was subjected to the glyoxal dehydration treatment in May 1992. Prior to this treatment, the coffin was preserved through the spray method described above. Although no shrinkage had been found during the course of the fifteen years, some fissures on the coating had been found; the foot crosspiece was cracked; there was local cracking on the inside wall of the coffin; the yellow paint of the patterns had fallen away to a large extent; and the paint coating had chipped in various locations.

The Preservation State of the Outer Coffin from the Tomb of the Marquis Yi

The outer coffin from the tomb to the Marquis Yi was treated in January 1993. There are twelve copper tenons on the four corners of the upper portion and on the two sides of the middle portion. There are ten copper tenons on the lower part. The coffin was originally coated with lacquer, and then colored patterns were drawn above the layer of lacquer. After fifteen years of being treated with water spraying, the two ends of the lid had decayed and cracking was found on the coating. There was also slight cracking on the body and a small number of fissures on the crosspiece. A small part of the coating had come off the inside wall and the middle part of the bottom plank had decayed.

The Preservation State of the Inner Coffin from the Tomb at Baoshan

The inner coffin from the tomb at Baoshan was treated by means of glyoxal dehydration in September 1991. Although the silver color, visible on the decorative patterns when the coffin was unearthed, had soon faded away, the yellow and gold colors on the decorative patterns remained as fresh as at the beginning of the five-year conservation period.

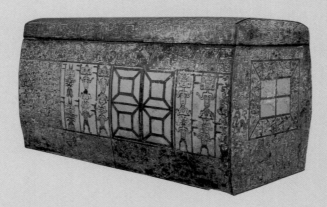

Inner coffin of Marquis Yi

Dehydration of the Inner Coffin from the Tomb of the Marquis Yi

The coffin lid was placed in a plastic tank, to which was then added a half-ton of the specially prepared glyoxal mixture. The unit weight of the liquid mixture was measured. The liquid was then agitated once every twenty days so as to facilitate the permeation of the liquid into the lid, and the unit weight of the liquid re-measured. When the unit weight became constant, the permeation of the glyoxal liquid mixture was complete. At that time, the liquid in the tank was renewed. The immersion continued until the unit weight was again constant, again demonstrating that the water in the lid had been replaced by the glyoxal dehydration liquid and that the saturation state had been reached. The liquid was then taken out of the tank. At that time, the polyreaction of glyoxal took place, and the water gradually escaped from the lid. When the moisture disappeared, the dehydration and shape-fixing of the lid was complete.

The body of the inner coffin was put into a tank specially made of plastic and then clear water was added. The immersion lasted six months. The water content of the coffin had decreased over the fifteen years of water treatment, and that state of desaturation caused the decrease in the bond of the lacquer coating with the solid base, and a part of the paint coating had reached a state of dryness. The purpose of the immersion with clear water was to put the coffin back into its original state of saturation so as to strengthen the affinity of the coating with the base and to increase the osmotic pressure within the cell cavity. The immersion aided in the prevention shrinkage induced by the large-scale decrease of osmotic pressure.

The plastic tank was next pumped dry, and four tons of specially prepared glyoxal liquid were added, and the unit weight of the liquid measured. During the immersion, the dehydration liquid was pumped out of the tank with a stainless steel pump and replaced once every ten days, so that the dehydration liquid would be in a uniform state and the permeation could be accelerated. When the unit weight of the liquid reached a constant value, the liquid was renewed. Then the immersion was continued until the unit weight became constant again, at which point the coffin body was removed from the tank and drying began.

Dehydration of the Outer Coffin from the Tomb of the Marquis Yi

The outer coffin of the tomb of the Marquis Yi has a copper frame structure. The glyoxal dehydration liquid was not used

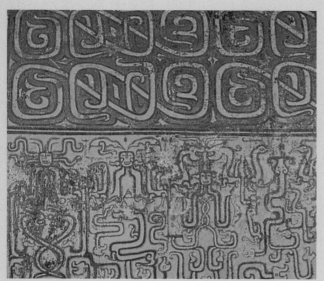
Inner coffin of the Marquis Yi

with this portion of the coffin so as to avoid damage to the copper.

After being excavated, the outer coffin had been wrapped with plastic film and continuously sprayed with water, thus lowering the water content. A low-concentration aqueous solution with a pH value of nine was prepared and applied to the coffin planks through dripping until the saturation state was reached. This process took approximately six months. Then the specially prepared glyoxal liquid was dripped on to the coffin planks until the coffin was saturated with the liquid, which took approximately one year. After the polyreaction occurred, the drying began.

Dehydration of the Inner Coffin from the Tomb at Baoshan

The lid and body of the inner tomb from the tomb at Baoshan were placed inside a plastic tank, and then over a half-ton of specially prepared glyoxal dehydration liquid was added. The unit weight of the liquid was measured. During the permeation of the dehydration liquid, the liquid was regularly agitated so as to accelerate the permeation. When the unit weight of the liquid was constant, the liquid was renewed. The immersion was continued until the completion of the permeation. The lid and body were then removed from the tank, the glyoxal polyreaction occurred, and the drying treatment followed.

Results

The use of the technique on these two tombs proved to be a success. After the glyoxal treatment, the painted coffins continue to have color and luster as fresh as if they had not undergone the treatment, and are in good condition. The chipping paint and cracking were repaired with raw lacquer, a strong adhesive, and an epoxy resin after the treatment. Since the treatment, no cracking or shrinking has taken place, and the strength of the wood has increased.

brown. We must imagine the Baoshan coffin, for example, as even brighter than it appears today, with silver that has now tarnished.

The craftsmanship and wit of utilitarian wares found in these burials convey that even in objects such as a picnic set-containing bottles, cups, and a dish-aristocrats enjoyed high style. The picnic set-found in the chamber of the Baoshan Tomb #2 described in the tomb inventory slips as the chamber containing "objects one would take traveling"-is a charming example. The outer case, with its carved coils, suggests stylized reptile skin. Pl. 91

GLASS

Glass appeared in China during the Warring States period. The glass beads in this exhibition are of the lead flux type. An understanding of early glass, such as that found in the Marquis Yi's tomb, is only now becoming clear. Pl. 76

IRON

Nominally, the Bronze Age ended in the 3rd century B.C., with the appearance of the first iron implements. Iron, however, only gradually came into common use, replacing the more valuable bronze in weapons. Iron technology in China relied on cast iron rather than forged iron, which was not common in China until the Middle Ages.

The luxury treatment of iron is seen in the exhibition in the large, inlaid fabric hook. Gold and silver dragons and eleven birds are set in a ground of curvilinear and spiralling lines. Pl. 82

Although only the gold inlay remains visible on the corroded surface, both gold and silver strips were set into pre-cast depressions. More parallel strips were added depending on the desired width of the line. At almost a kilogram, this object was too large to be comfortably worn by a person; other possible uses were as part of a horse fitting or for holding curtains. Some archaeologists have suggested that it was made for display, a suggestion only plausible in a culture of licensed indulgence in luxury goods.

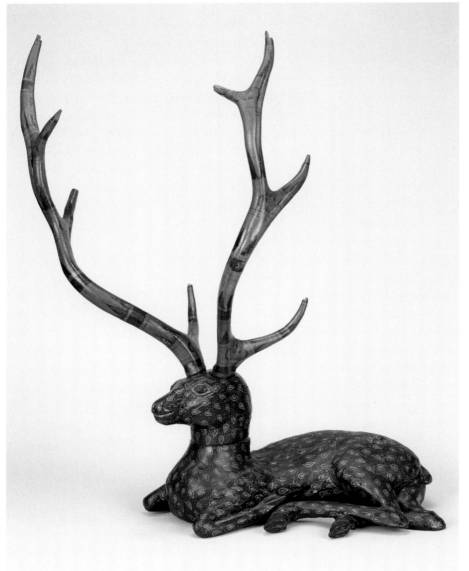

a

Plate 83

漆梅花鹿

**DEER FROM
SUIXIAN TOMB #1**
5th century B.C.,
Early Warring States period
Painted lacquer over wood
with sika deer antlers,
77 x 27 x 45 cm

b

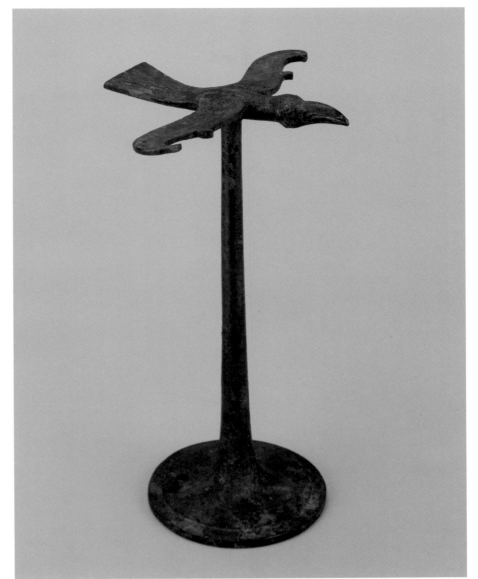

Plate 84

銅飛鳥

**FLYING BIRD FROM
BAOSHAN TOMB #2**
4th century B.C.,
Late Warring States period
Bronze, 21.4 x 6 cm

a

b

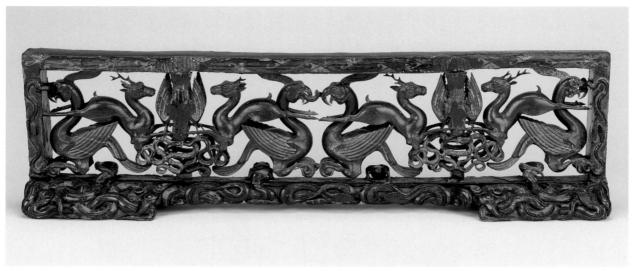

a

b

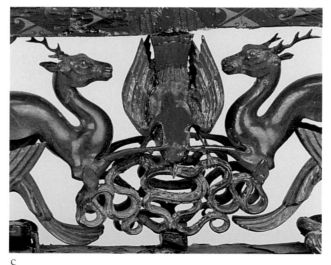

c

Plate 85

漆木雕小座屏

SMALL SCREEN FROM WANGSHAN TOMB #1

4th century B.C., Middle Warring States period
Painted lacquer over wood, 51.8 x 15 cm

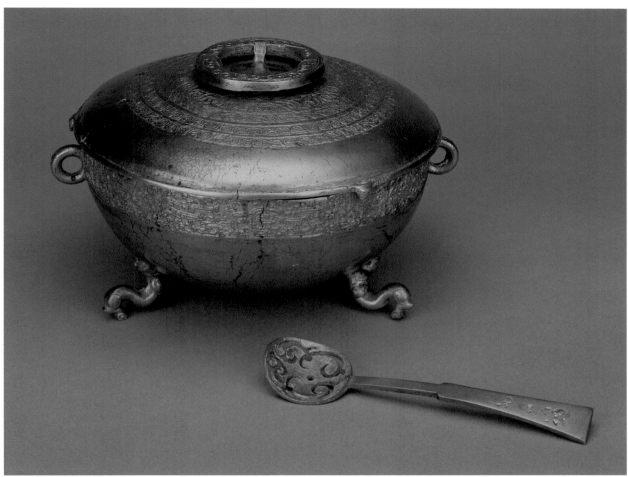

a

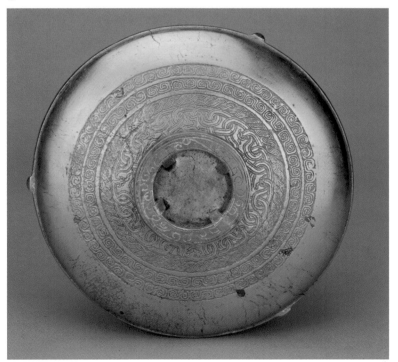

b

Plate 86

金盞（附金漏匕）

**COVERED FOOD BOWL
WITH SLOTTED SPOON
FROM SUIXIAN TOMB #1**
5th century B.C.,
Early Warring States period
Gold, 11 x 15.7 cm (bowl),
13 x 3.4 cm (spoon)

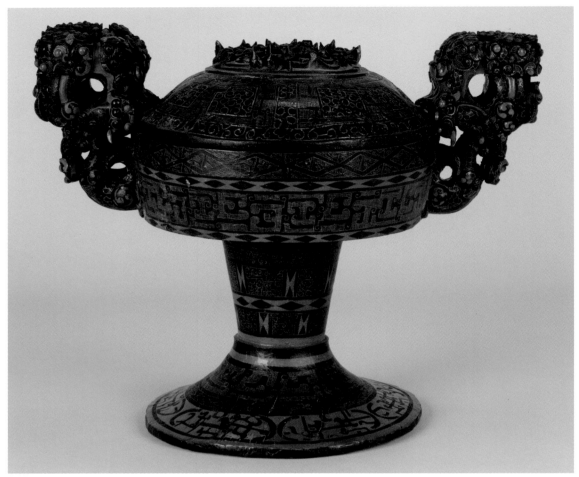

a

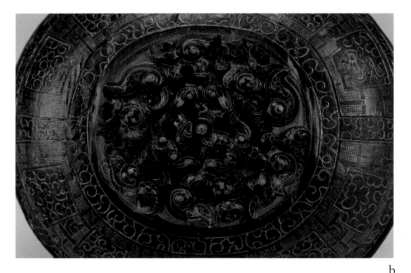

b

Plate 87

漆蓋豆
LIDDED FOOD VESSEL FROM SUIXIAN TOMB #1
5th century B.C., Early Warring States period
Painted lacquer over wood, 28.3 x 21.6 cm

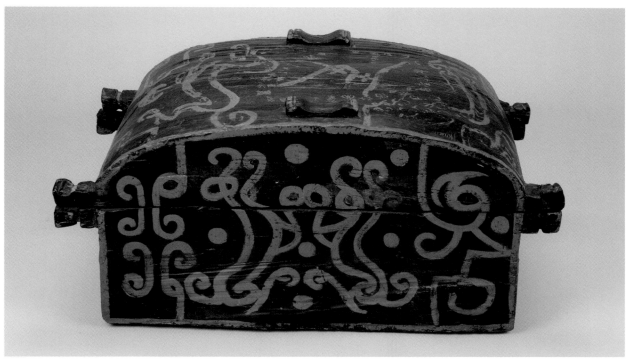

a

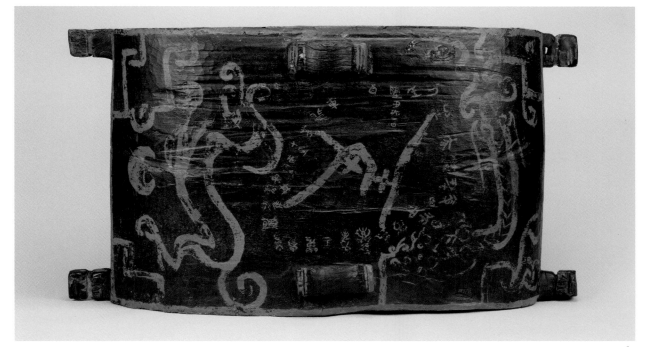

b

Plate 88

廿八宿衣箱

CHEST FROM SUIXIAN TOMB #1
5th century B.C., Early Warring States period
Painted lacquer over wood, 40.5 x 71 x 47 cm

a

b

Plate 89

曾侯乙墓絲織品殘片
**TEXTILE FRAGMENTS
FROM SUIXIAN TOMB #1**
5th century B.C.,
Early Warring States period
Silk, varied dimensions

124

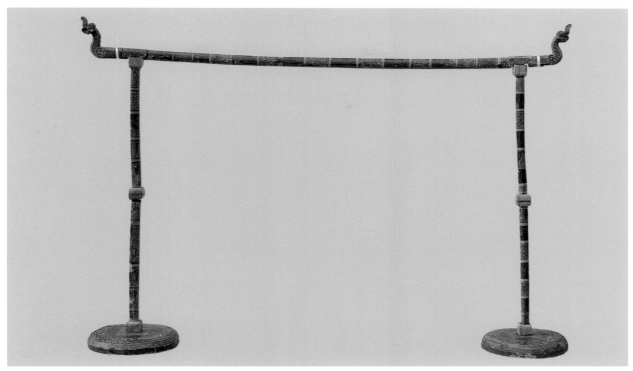

a

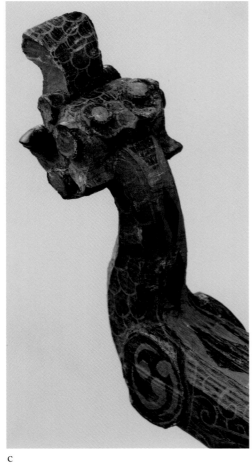

c

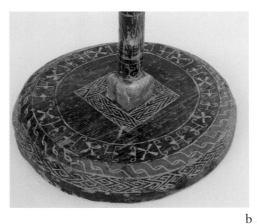

b

Plate 90

漆架

RACK FROM SUIXIAN TOMB #1
5th century B.C., Early Warring States period
Painted lacquer over wood, 181.5 x 264 cm

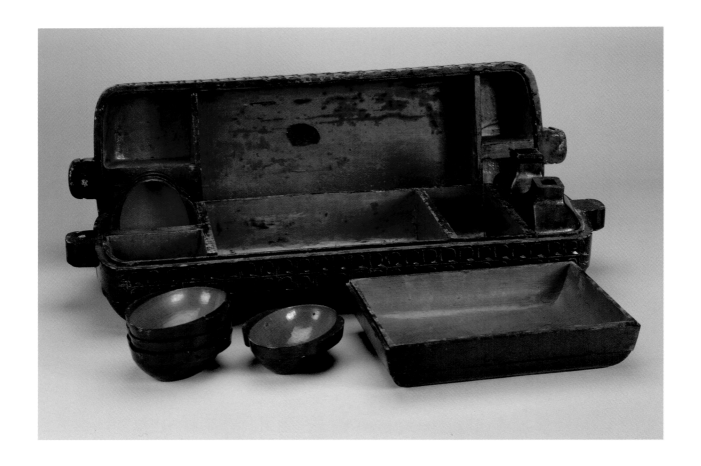

Plate 91

漆酒具盒

BOX WITH CUPS AND TRAYS FROM BAOSHAN TOMB #2
4th century B.C., Late Warring States period
Painted lacquer over wood, 19.6 x 71.5 x 25.6 cm

a

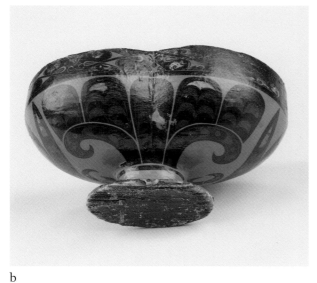

b

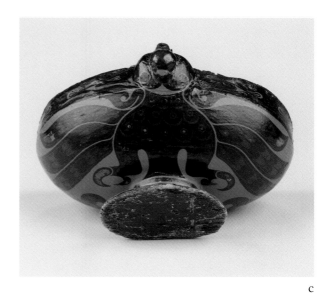

c

Plate 92

漆鳥喙形杯

CUP WITH BIRD SPOUT FROM BAOSHAN TOMB #2
4th century B.C., Late Warring States period
Painted lacquer over wood, 10 x 19.3 cm

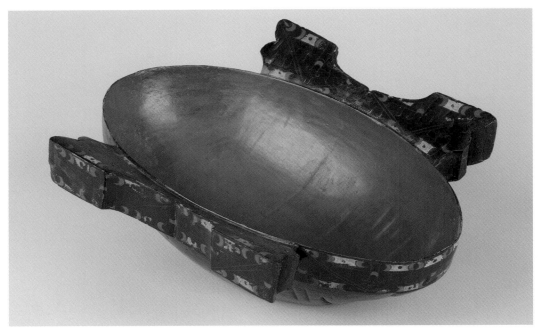

a

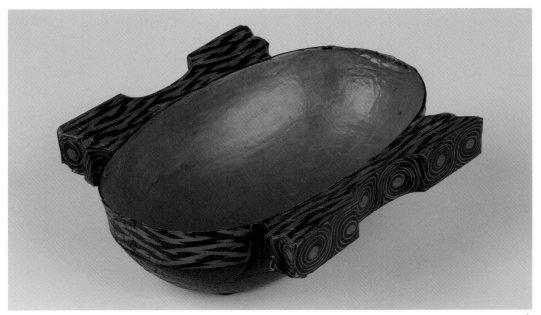

b

Plate 93

漆耳杯
沙塚
望山

**FOUR CHU CUPS
(TWO FROM SHAZHONG TOMB, TWO FROM WANGSHAN TOMB #1)**
4th century B.C., Middle Warring States period
Painted lacquer over wood, varied dimensions

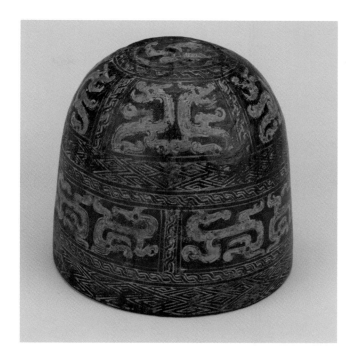

Plate 94

漆杯形器

CUP FROM SUIXIAN TOMB #1
5th century B.C., Early Warring States period
Painted lacquer over wood, 11.2 x 11.8 cm

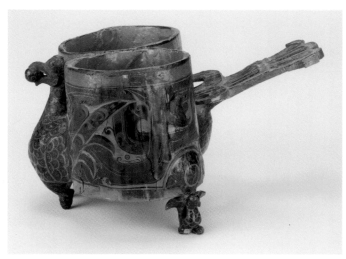

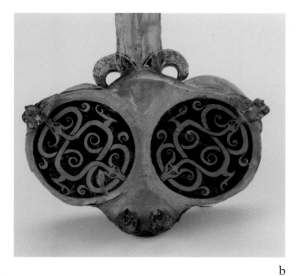

a

b

Plate 95

漆杯

TWIN CUP FROM BAOSHAN TOMB #2
4th century B.C., Late Warring States period
Painted lacquer over wood, 9.2 x 17.6 x 14 cm

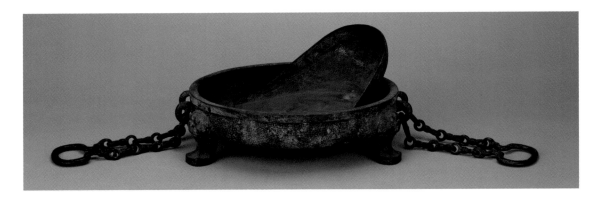

Plate 96

銅炭盤銅箕

BRAZIER AND DUSTPAN FROM WANGSHAN TOMB #1
4th century B.C., Middle Warring States period
Bronze, varied dimensions

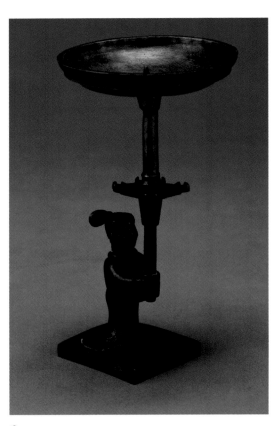

a

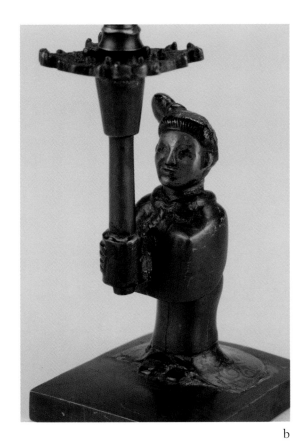

b

Plate 97

人擎銅燈

LAMP STAND FROM BAOSHAN TOMB #2
4th century B.C., Late Warring States period
Bronze, 16.3 x 8.6 x 7.1 cm

130

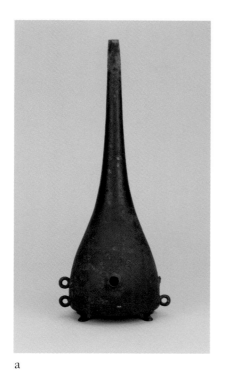
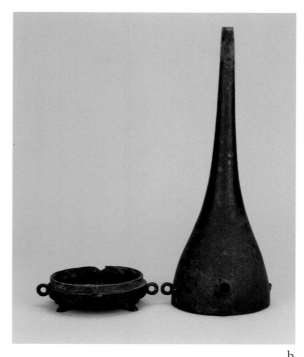

a b

Plate 98

銅熏

INCENSE BURNER FROM SUIXIAN TOMB #1
5th century B.C., Early Warring States period
Bronze, 42.8 cm

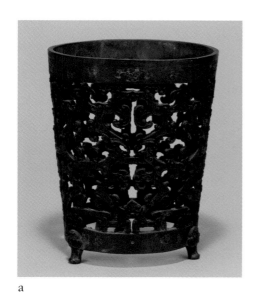

a b

Plate 99

銅熏

INCENSE BURNER FROM BAOSHAN TOMB #2
4th century B.C., Late Warring States period
Bronze, 14.6 x 11.7 cm

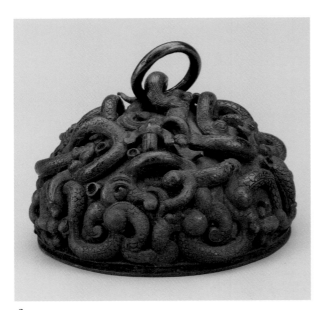
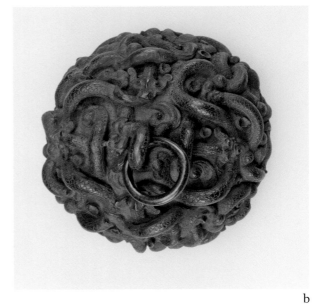

a b

Plate 100

銅鎮

MAT WEIGHT FROM SUIXIAN TOMB #1
5th century B.C., Early Warring States period
Bronze, 8 x 11.8 cm

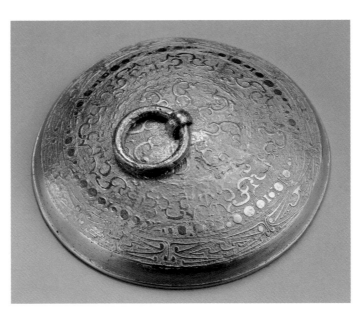

Plate 101

金鎮

WEIGHT FROM SUIXIAN TOMB #1
5th century B.C., Early Warring States period
Gold, 2.8 x 9.5 cm

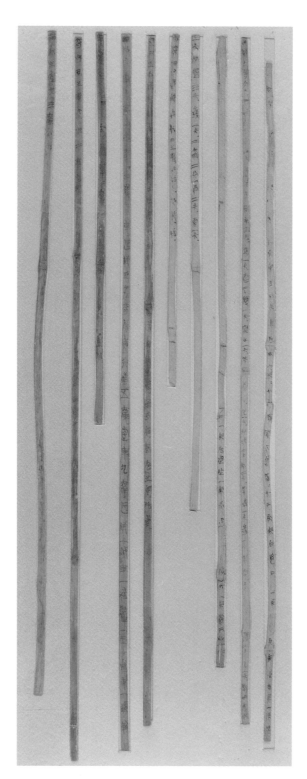

Plate 102

竹簡

TEN INVENTORY RECORDS FROM SUIXIAN TOMB #1

5th century B.C., Early Warring States period

Ink on bamboo, varied dimensions